IMAGES
of Rail

ARCADE AND
ATTICA RAILROAD

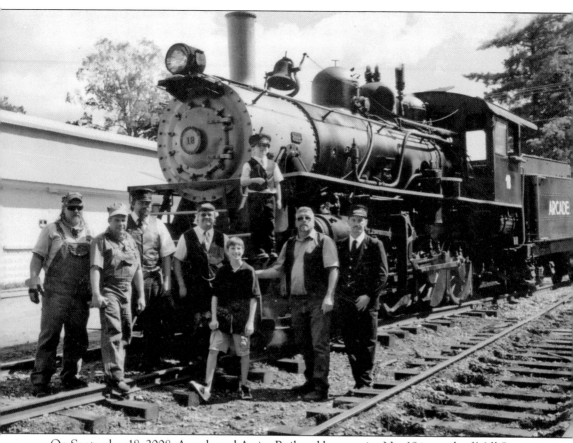

On September 18, 2008, Arcade and Attica Railroad locomotive No. 18 is north of Mill Street in Arcade with Mitchell Ling on the locomotive and, from left to right, Dennis Horner, fireman; Brad Mapes, engineer; Sam Kish, conductor; Dean Steffenhagen, conductor; Jon Thomas Robertson, the boy whose wish to have the railroad handicapped accessible came true; George Ling, general manager; and Patrick D. Connors, conductor. (Photograph by Kenneth C. Springirth.)

On the cover: Arcade and Attica Railroad locomotive No. 6 is on the wye at Attica on the Railroad Enthusiasts, Inc., New York Division excursion of June 16, 1940. An Erie Railroad passenger train was passing by at this interchange point. This locomotive operated until 1946 with replacement by diesel locomotives. (Patrick D. Connors collection.)

IMAGES
of Rail

ARCADE AND
ATTICA RAILROAD

Kenneth C. Springirth

ARCADIA
PUBLISHING

Published by Arcadia Publishing
Charleston, South Carolina

Printed in the United States of America

Library of Congress Control Number: 2009927170

For all general information contact Arcadia Publishing at:
Telephone 843-853-2070
Fax 843-853-0044
E-mail sales@arcadiapublishing.com
For customer service and orders:
Toll-Free 1-888-313-2665

Visit us on the Internet at www.arcadiapublishing.com

This book is dedicated to the author's granddaughter Rebecca Michelle Springirth, shown with her parents Robin Springirth and Philip Springirth on May 24, 2009. Her wide-eyed curiosity encouraged the writing of this book with the goal of preserving the history of the Arcade and Attica Railroad for future generations. (Photograph by Kenneth C. Springirth.)

ACKNOWLEDGMENTS

Thanks to the management and employees of the Arcade and Attica Railroad for their consistent hard work and willingness to take the extra time and effort to preserve an important part of western New York railroad history. George Ling, general manager of the Arcade and Attica Railroad, and his wife Trudy Ling, who handles public relations and a variety of other duties, provided information and pictures of the railroad. The personal scrapbook of Donald G. King loaned to the railroad by his son Donald King was an excellent source of background information on the railroad. Patrick D. Connors, president of the Friends of the Arcade and Attica Railroad, Inc., supplied information and pictures. Chris Lester, vice president of the Friends of the Arcade and Attica Railroad, Inc., supplied information and pictures. Jeffrey C. Mason, historian of the town and village of Arcade and treasurer of the Arcade Historical Society, for information and pictures from his collection and from the Arcade Historical Society, including its newspaper file. Louis A. Magnano, president and chief executive officer of Park Centre Development, Inc., and Vicki L. Blessing, vice president of leasing and development of Park Centre Development, Inc., and Oliver J. Ogden of the Museum of Bus Transportation for information on Blue Bird Coach Lines, Inc. Other sources of pictures were Kenneth Lehman, Lucy Monthie, Harold K. Vollrath, Harry S. Douglass, Vic Neal, Richard F. Nashold, Ken Kraemer, Patrick Burns, Jon Patton, Duncan Richards, Roland Gillis, Cecil A. Lester, Hugh P. Ely, Devan Lawton, John C. Vought, and Motor Bus Society Library collection. Herbert Wildman and Donald Kaverman provided some reference information. The Arcade Free Library was a source for information from old newspapers. Thanks to George Ling, Trudy Ling, Patrick D. Connors, Chris Lester, and Jeffrey C. Mason for proofreading the text.

The Arcade and Attica Railroad, 278 Main Street in Arcade, New York 14009, is an authentic short-line "common carrier" (carrying passengers and freight) railroad. For the latest information the railroad has a Web site at www.arcadeandatticarr.com, and the telephone number is 585-492-3100. Throughout the year the railroad operates freight service and welcomes new freight customers. The railroad serves southwestern Wyoming County. It should be noted that the railroad management greatly appreciates the volunteers who have served as conductors plus the crew of regular volunteers who help make the special events on the railroad really special.

INTRODUCTION

About 40 miles southeast of Buffalo in the beautiful rolling hills of southwestern New York's Wyoming County and headquartered in the lovely village of Arcade is the Arcade and Attica Railroad, which is the oldest continuously operating railroad under the same corporate identity in New York State. Running 15 miles from Arcade north through the ubiquitous farmland of Tonawanda Valley to North Java, this is the only railroad in New York State that operates summertime steam locomotive passenger service. All year long the railroad provides diesel-powered freight service. With passenger service in the United States operated by government-supported Amtrak, this is one of the few remaining private common carrier railroads that operate passenger service. The key ingredient has been the hardworking, resourceful, and productive workforce that keeps a railroad running with vintage equipment. It took a struggle to get the railroad built, and survival of the railroad has not been easy.

On November 4, 1852, the Attica and Allegheny Valley Railroad was organized to build a three-foot narrow-gauge railroad from Attica south via Arcade to Pennsylvania. Grading was started, but construction stopped in 1855. The Attica and Arcade Railroad was incorporated on February 28, 1870, to build a line from Attica to Arcade but was not able to raise the capital to build the line. On April 5, 1880, the Tonawanda Valley Railroad was incorporated and completed a three-foot narrow-gauge line from Attica to Curriers Corners (later renamed Curriers) on September 11, 1880. Construction proceeded southward with trackage to Arcade completed on May 12, 1881, and revenue service to Arcade began on May 16, 1881. The Tonawanda Valley and Cuba Railroad was formed on July 14, 1881, and completed the line south to Cuba, New York, on September 4, 1882. Financial problems, decrease in traffic, and severe winter snowstorms resulted in closure of the line on December 1, 1885. Starting on April 1, 1886, there was infrequent service until October 16, 1886, when operation south of Sandusky was discontinued. On January 19, 1891, the Tonawanda Valley and Cuba Railroad was sold. The Attica and Freedom Railroad was formed but only operated the line from Attica to Freedom with the section south to Cuba abandoned. Mounting deficits forced the line into bankruptcy. It was sold on March 3, 1894. On October 13, 1894, the Buffalo, Attica and Arcade Railroad was organized and rebuilt the line to the standard gauge of four feet, eight and a half inches. Effective January 9, 1895, two trains were operated in each direction from Attica to Curriers. Service from Attica to Arcade began on December 1, 1895. By 1897, a two-mile connection was completed from Arcade to Arcade Junction to have an interchange with the Western New York and Pennsylvania Railroad.

It should be noted that on October 25, 1871, the Buffalo, New York and Philadelphia Railroad operated its first train from Buffalo to Arcade. In September 1887, this became the Western

New York and Pennsylvania Railroad and was acquired by the Pennsylvania Railroad on July 31, 1900.

On October 7, 1902, the bridge over Clear Creek between Arcade and Sandusky collapsed under the weight of a gravel train. Lacking the financial resources and sufficient business to rebuild the bridge, the line was abandoned between Arcade and Freedom. In 1904, the Buffalo, Attica and Arcade Railroad became part of the Buffalo and Susquehanna Railway, which completed its line from Buffalo to Wellsville during 1906 but closed that line on November 17, 1916. Interchange with the Buffalo and Susquehanna Railroad was near today's Arcade engine house. The Buffalo, Attica and Arcade Railroad ended service on March 10, 1917.

Alarmed that the railroad might be abandoned, local farmers and merchants began to raise money to purchase the railroad. The *Wyoming County Herald* newspaper for March 30, 1917, reported that $90,000 had been raised and an additional $10,000 was needed. In the April 20, 1917, *Wyoming County Herald* newspaper, E. J. Conroy, chairman of the stock subscription committee, reported that $100,000 had been raised to purchase the Buffalo, Attica and Arcade Railroad. Conroy urged farmers to plant every acre they could in potatoes to furnish freight for the railroad. On May 25, 1917, the Buffalo, Attica and Arcade Railroad was sold to the subscription committee at Warsaw, New York. The June 1, 1917, *Wyoming County Herald* newspaper noted the board of directors of the new Arcade and Attica Railroad elected president Paul Quinn, vice president E. J. Conroy, and secretary treasurer George E. Hogue. Service resumed on June 1, 1917. The *Arcade Herald* newspaper of February 22, 1929, noted that for the first time in the Arcade and Attica Railroad's history a dividend was declared. During 1929, the railroad purchased 45 acres of land bordering on the proposed state prison for Attica. The March 8, 1929, *Arcade Herald* newspaper reported the railroad would install a new switch into the prison and land would be sold to New York State to complete the site for the prison. The railroad weathered the hard economic times of the 1930s with an increase in business while reducing operating expenses as reported by its stockholders meeting of February 19, 1938. In June 1941, the railroad purchased new diesel locomotive No. 110 to replace steam locomotive No. 7 and retained steam locomotive No. 6 as a standby. An early 1947 spring derailment caused by a washout one half mile south of Johnsonburg where a section of track was left without a foundation necessitated major repairs to No. 110. A second diesel locomotive, No. 111, was purchased in 1947, making the 28-mile Arcade and Attica Railroad one of the first railroads in the United States to be completely dieselized. Steam locomotive No. 6 was sold for scrap. The new diesels reduced the railroad's fuel, water, and labor bills.

In the first four months of 1951, only eight passengers were carried for total revenue of $1.80. Passenger service was abandoned on August 1, 1951. The Erie Railroad, which had connections with the Arcade and Attica Railroad at Attica, had discontinued its Buffalo to Hornell passenger service in February 1951. Heavy rain resulted in the washout of several hundred feet of track south of Attica on January 23, 1957. The railroad then decided to abandon the section of line from North Java to Attica during 1957, leaving 15 miles in service from Arcade to North Java. Despite that abandonment, the line was still profitable in 1957. Richard I. Cartwright was elected president of the Arcade and Attica Railroad at the railroad's April 4, 1959, stockholders meeting. The April 9, 1959, *Arcade Herald* newspaper noted that Cartwright started with the Buffalo, Arcade and Attica Railroad on September 1, 1912, and continued with the Arcade and Attica Railroad becoming general manager on November 21, 1921. He was elected to the board of directors during February 1931 and elected secretary treasurer in November 1933.

Freight revenues declined, and the railroad needed to find additional revenue. Richard I. Cartwright, president of the Arcade and Attica Railroad, conducted a nationwide search for a steam locomotive and located No. 18 from the Boyne City Railroad in Michigan. Officers of the railroad, reporters, politicians, and businessmen boarded two orange and black passenger cars for a preview steam run on July 27, 1962. On August 4, 1962, steam engine No. 18, piloted by Bud King and his brother Donald King, inaugurated passenger excursion service from Arcade to Curriers. In the first three weeks of operation, the excursion trains carried 4,000 passengers.

By September 30, 1962, the railroad had four passenger coaches and was seeking a second steam locomotive for standby purposes. The excursion service added needed revenues. At the 47th annual meeting of the corporation on April 6, 1963, railroad president Cartwright noted that 17,890 passengers were carried during the 27 days of tourist passenger service in 1962. Financially it was the most successful year for the railroad in a decade. A second steam locomotive, No. 14, was obtained during 1963 from the Escanaba and Lake Superior Railroad that operated in Michigan and Wisconsin. It was placed in service on August 14, 1964. On April 2, 1966, Richard I. Cartwright, president of the Arcade and Attica Railroad, retired after 54 years of service on the line, and Edward A. Lewis became general manager.

The Pennsylvania Railroad, which the Arcade and Attica Railroad interchanged with at Arcade, merged with the New York Central Railroad and became the Penn Central Transportation Company on February 1, 1968. Following bankruptcy of the Penn Central Transportation Company on June 21, 1970, under the Railroad Revitalization and Regulatory Reform Act of 1976, Penn Central Transportation Company became part of the Consolidated Rail Corporation (Conrail). In 1999, CSX and Norfolk Southern Railway jointly purchased Conrail and split up its mileage. The line through Arcade became Norfolk Southern Railway, which has leased the trackage to the Buffalo and Pittsburgh Railroad. Meanwhile on the Arcade and Attica Railroad in 1969 freight traffic averaged over 200 carloads per month. The November 18, 1970, *Tri County Times* reported that 1970 was the best year for passenger traffic with "more than 37,000 passengers from England to California riding the train." Freight revenues declined from $81,107 in 1972 to $77,349 in 1973, while passenger revenues increased from $52,699 in 1972 to $63,300 in 1973. The number of passengers increased from 35,370 in 1972 to 42,578 in 1973.

When general manager Edward A. Lewis accepted a position with another railroad, Cecil A. Lester (who started with the railroad in 1957) was named superintendent in charge of train crew, track crew, and the shop during 1973. In the March 6, 1974, *Tri County Times* newspaper, Gerald G. Hutton, president of the Arcade and Attica Railroad, announced the new general manager would be Ruth Tanner (daughter of Richard I. Cartwright, the former general manager and president until he retired in 1966). On March 5, 1976, the surging Cattaraugus Creek destroyed about 400 feet of track, cutting off the Arcade and Attica Railroad from its interchange with the Penn Central Transportation Company at Arcade. Repairs were made to restore that link. During 1981, the Arcade and Attica Railroad was listed on the National Register of Historic Places. In 1988, a 65-ton diesel locomotive was purchased from the City of Colorado Springs Power Authority. Renumbered No. 112, it replaced diesel No. 110.

David Copeland became general manager during 1987. In 1994, Linda Kempf was hired as general manager responsible for advertising, promotions, accounting, management, customer service, and freight service. For a six-year period beginning in 2002, locomotive No. 18 was refurbished to comply with new federal safety regulations. Diesel locomotive No. 112 was refurbished to handle passenger excursion duties. In 2007, general manager Linda Kempf retired. George Ling, appointed general manager during 2007, and his wife Trudy Ling, who handles public relations, with a dedicated workforce have done an excellent job in making sure this railroad continues to be an important lifeline to the industry it serves.

On March 25, 2008, the Arcade Village Board granted permission to the Friends of the Arcade and Attica Railroad, Inc., (following a presentation by its vice president Chris Lester) to construct a permanent historical train display in the municipal parking lot behind the Main Street stores in Arcade. Lester noted that the display would be 10 feet by 120 feet and consist of a 1941 diesel, a 1920s boxcar, and a 1915-era caboose. Construction began on April 5, 2008, and the volunteer group completed it with help from the railroad. On Saturday, April 19, 2008, a ceremonial run was made across Main Street by refurbished steam locomotive No. 18. The *Arcade Herald* newspaper of April 24, 2008, noted, "A & A general manager George Ling and his wife Trudy, along with members of the railroad's Board of Directors, crew, and not for profit arm Friends of the A & A gathered excitedly as engineer Brad Mapes climbed the cab of the 1920 2-8-0 American Locomotive Company steam engine. Smiles were as plentiful as pieces of coal in

the engine's firebox as its return to service after a six year absence was celebrated." On May 24, 2008, steam locomotive No. 18 returned to power the excursion service.

"Extreme Makeover Visits Arcade & Attica" was the headline in the September 25, 2008, *Arcade Herald* newspaper, which reported, "Townspeople, shopkeepers and students at Arcade Elementary School jammed Main Street in Arcade on Thursday September 18 to be part of Extreme Makeover-Home Edition's big reveal at the Arcade & Attica railroad." Jon Thomas Robertson, a 12-year-old boy from Cuba, New York, since he was 8 years old had been taking empty aluminum pop cans to a recycling center for cash to buy tickets so underprivileged and handicapped children could ride the railroad's passenger excursions. Over a period of time the railroad had been working to become handicapped accessible. Community involvement including volunteers from the Christian Youth Corps organized by Pete Andrews painted the outside of the historic train station. As an author working on this book it was incredible to witness the outpouring of the community in its participation in the event that celebrated the completion of the handicapped accessibility project by the railroad and its volunteers.

The Arcade and Attica Railroad has avoided merger and consolidation with larger railroads and has continued to be a lifeline for the Reisdorf Brothers Feed Mill at North Java. A dedicated management who has felt a strong sense of public responsibility with the willingness to take the time and effort to preserve the railroad plus the pride and devotion of the employees has made it possible for this railroad to continue and weather economic slumps. This unique railroad makes a historical and economic contribution to the vitality of Wyoming County.

When excursion service started in 1962, the Pennsylvania Railroad provided passenger service to Arcade on its Buffalo to Harrisburg line. Pennsylvania Railroad commuter service from Arcade to Buffalo made its last run on January 24, 1948. Arcade was easily reached by frequent bus service from Olean and Buffalo. On December 3, 1926, an application was approved for the Wellsville–Buffalo Lines, Inc., to operate bus service through Arcade. This later became part of the Greyhound bus system. In 1963, Blue Bird Coach Lines, Inc., acquired the Olean–Buffalo rights of Greyhound. Joseph Magnano established the Blue Bird Cab Company in Olean in 1920 and founded Blue Bird Coach Lines in 1941, which operated a bus system in Olean and grew into a company that had charter rights in 48 states and had regular route intercity bus service. The United States Department of Transportation–Surface Transportation Board approved the acquisition of Blue Bird Coach Lines, Inc., by Coach USA, Inc., on June 19, 1998. In 2009, Coach USA, Inc., from Buffalo via Arcade to Olean operates three round-trips Monday through Friday, two round-trips on Saturday, and one round-trip on Sunday. The Arcade and Attica Railroad station in Arcade serves as the bus station.

One

RAILROAD HISTORY

The Arcade and Attica Railroad is a 15-mile common carrier railroad that had its beginnings in the mid-1850s as a number of failed railroads tried to build a three-foot narrow-gauge railroad from Attica via Arcade to southern New York. The route through the Tonawanda Valley in Wyoming County involved the following unsuccessful railroad companies: the Attica and Sheldon Railroad, the Attica and Allegheny Valley Railroad, the Attica and Arcade Railroad, the Tonawanda Valley Railroad, the Tonawanda Valley and Cuba Railroad, and the Attica and Freedom Railroad. Finally, under the Buffalo, Attica and Arcade Railroad, the line was converted to the standard gauge of four feet eight and a half inches. With concern that this railroad would abandon service, local interests formed the Arcade and Attica Railroad on May 23, 1917. Severe washouts resulted in the abandonment of the line from North Java to Attica in 1957. The railroad had a profit of $1,950 in 1957 but lost money every year after that until it began steam passenger service in 1962, recording a profit of $656. The February 25, 1988, *Arcade Herald* newspaper reported the delivery of locomotive No. 112 on February 19, 1988, noting that the locomotive arrived aboard a flatcar on the track at the Conrail interchange. Winters Railroad Service of Langford positioned a bulldozer on each side of the locomotive. Cranes lifted the locomotive upward, and then it was carefully lowered on the track.

For eight years, steam locomotive No. 18 was out of service and steam locomotive No. 14 handled the passenger service. The *Arcade Herald* newspaper of June 1, 1989, reported No. 18 was returned to service on May 25, 1989, with the tender from No. 14 transferred to locomotive No. 18. From autumn 2001 to April 2008, No. 18 was out of service and rehabilitated to meet new Federal Railroad Administration safety rules. George Ling, the current general manager, and his wife Trudy Ling, who handles public relations, have injected new life into the railroad. During 2008, there was a massive program funded by the New York State Department of Transportation to upgrade the railroad track to keep the service in place.

The Tonawanda Valley Railroad.

TIME TABLE No. I.

Distance.	TRAINS NORTH.	A. M.	P. M.	Distance.	TRAINS SOUTH.	A. M.	P. M.
	Lv. CURRIER'S......	7.00	2.00		Lv. ATTICA	10.30	7.00
2 38	JAVA CENTRE..	7.10	2.13	3 26	" *SIERK'S..........	10.45	7.13
5 91	" NORTH JAVA...	7.24	2.30	5 65	" *EARL'S..........	10.58	7.23
6 51	" *PERRY'S.........	7.28	2.34	7 48	" VARYSBURG	11.08	7.31
9 54	" JOHNSONBURG .	7.40	2.50	9 59	" JOHNSONBURG .	11.20	7.40
11 65	" VARYSBURG....	7.50	3.02	12 62	" *PERRY'S.........	11.36	7.52
13 48	" *EARL'S..........	7.58	3.12	13 22	" NORTH JAVA ...	11.40	7.56
15 87	" *SIERK'S..........	8.07	3.24	16 75	" JAVA CENTRE..	11.58	8.10
19 13	Ar. ATTICA	8.20	3.40	19 13	Ar. CURRIER'S......	12.10	8.20

At Stations marked thus * Trains will stop only on signal.

☞ Trains on this Road run by New York Time.

J. V. D. LOOMIS,

ATTICA, Sept. 27th, 1880. Superintendent.

The Tonawanda Valley Railroad's first public schedule for September 27, 1880, shows two daily passenger trains from Attica to Curriers. On Saturday, September 11, 1880, the railroad formally opened with a free ride for all those who lived along the line and contributed toward building switches and shelters at stations located at Sierk's, Earl's, and Perry's. Men rode on piles of ties on flatcars. Ladies had a special ladies flatcar with board seats, sides, and a canopy top. Construction continued southward, and the track was completed from Attica to Arcade on May 12, 1881, with the first revenue passenger ticket issued on May 16, 1881. (Arcade and Attica Railroad collection.)

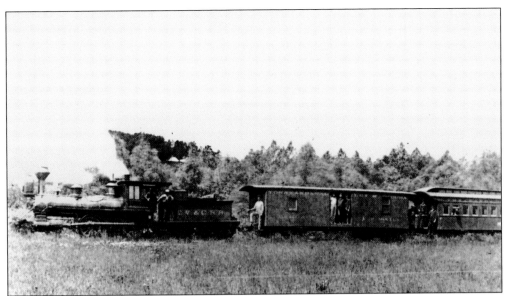

A Tonawanda Valley and Cuba Railroad train poses near Sandusky. Most of the railroad's locomotives were built by Brooks Locomotive Works and by Pittsburgh Locomotive Works. This was a three-foot narrow-gauge line built at a time when narrow-gauge lines briefly flourished. (Arcade Historical Society collection.)

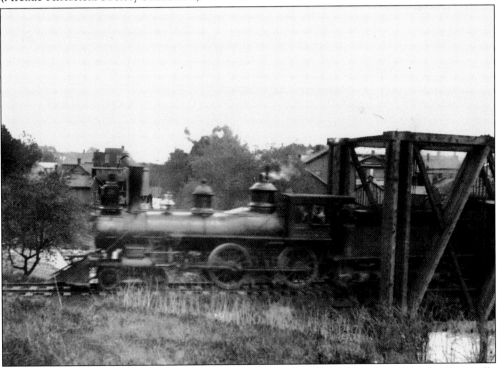

Buffalo, Attica and Arcade Railroad locomotive No. 2 is on the old trestle at Arcade. Originally built in February 1881 and acquired in 1894, this locomotive was previously New York, Lake Erie and Western Railroad No. 220. It was rebuilt by Grant Locomotive Works. (Arcade town historian collection.)

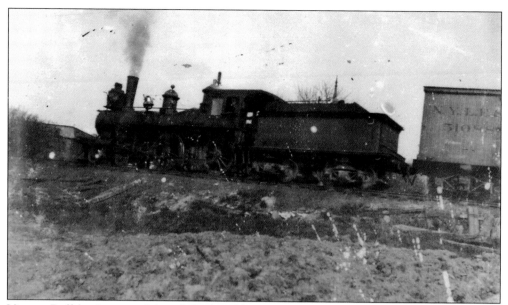

Vintage Buffalo, Attica and Arcade Railroad locomotive No. 2 is handling a freight run. With a 4-4-0 wheel arrangement, this locomotive had a two-axle leading truck followed by two driving axles. This was known as an American type locomotive due to the large number of these locomotives produced and used in the United States. (Arcade town historian collection.)

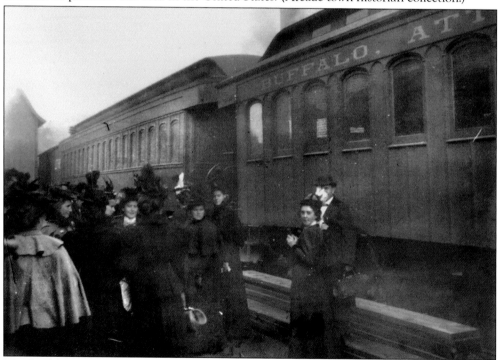

The Buffalo, Attica and Arcade Railroad operates its first standard-gauge train from Attica to Arcade on December 1, 1895. This was an important event for the community judging from the large number of people in formal attire around the train at Arcade. A railroad was considered an economic plus for a community. (Arcade town historian collection.)

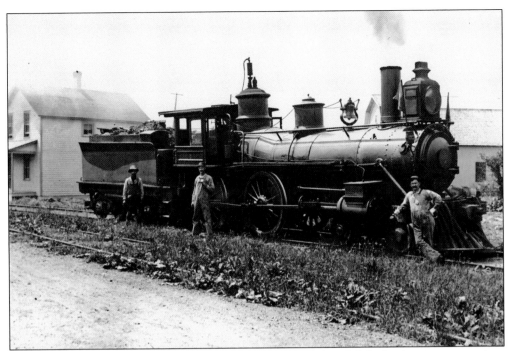

Buffalo, Attica and Arcade Railroad locomotive No. 4, with a 4-4-0 wheel arrangement, is at Arcade with the engine crew, from left to right, N. S. Dawley, Earl Jones, and Frank Colby. This was previously a Philadelphia, Wilmington and Baltimore Railroad locomotive built during 1873 and acquired in 1904. (Arcade and Attica Railroad collection.)

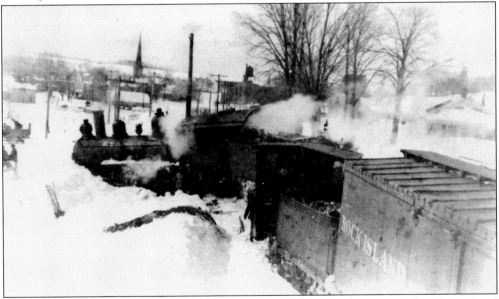

Near downtown Arcade in a heavy winter snow, two Buffalo, Attica and Arcade Railroad locomotives have derailed with the first locomotive No. 8, which had a 4-4-0 wheel arrangement. This is looking southwest with the Baptist church steeple on Main Street in view. The Rock Island boxcar was the Chicago, Rock Island and Pacific Railroad, which operated its last train on March 31, 1980. (Arcade Historical Society collection.)

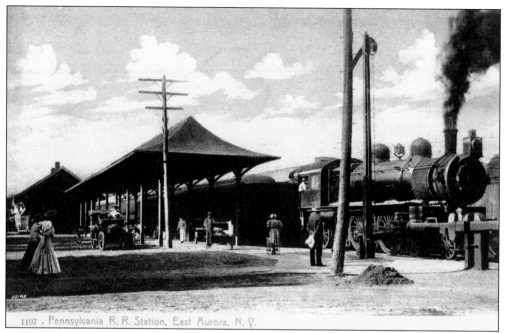

A Pennsylvania Railroad passenger train is at East Aurora in this postcard postmarked August 23, 1909. In 1916, there were three trains in each direction that connected Arcade with East Aurora on the Buffalo-to-Olean line of the Pennsylvania Railroad. In addition, there were two morning trains from Arcade to Buffalo and two evening trains from Buffalo to Arcade daily except Sunday. Railroad passenger service linked Arcade nationwide.

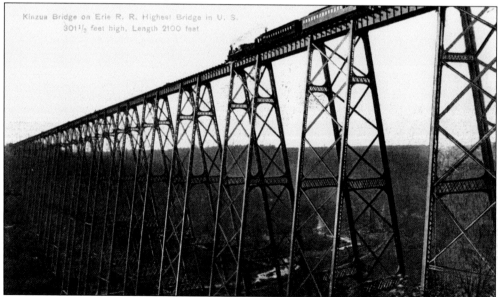

An Erie Railroad passenger train is crossing the 2,053-foot-long and 301.5-foot-high Kinzua Viaduct in Pennsylvania. When built during 1882, this was the world's highest and longest railroad bridge. It was rebuilt to handle heavier rail traffic and reopened on September 25, 1900. Arcade residents could reach this bridge via the Pennsylvania Railroad to Olean, the Erie Railroad to Carrollton, and the Erie Railroad to Kinzua Viaduct.

STATION NUMBERS	No. 101 First Class Daily	No. 7 First Class Sunday Only	No. 5 Mixed Daily Except Sunday	No. 3 First Class Daily Except Sunday	DISTANCE FROM ARCADE	STATIONS	DISTANCE BETWEEN STATS.	No. 2 First Class Daily Except Sunday	No. 4 Mixed Daily Except Sunday	No. 6 First Class Sunday Only	No. 108 First Class Sunday Only	No. 102 First Class Daily
	A. M.	A. M.	P. M.	A. M.				A. M.	P. M.	A. M.	A. M.	A. M.
28	8.50	10.47				Ar. Arcade P. R. R. Station Dep.					11.25	
29	8.40	10.44			B. A. & A. Jct............	.46				11.28	
27	8.35	10.40			Arcade B. & S. Station..........	1.56				11.32	
26	8.30	10.37	6.20	9.37	ARCADE..................	.33	6.30	12.30	6.30	11.35	
24	10.30 f	6.10f	9.30f	ARCADE CENTER..........	2.00	6.37 f	12.39f	6.37 f		6.50
19	8.05	10.17	5.55	9.17	6.78CURRIERS	4.78	6.50	1.00	6.50		7.15
16	7.50	10.11	5.45	9.11	9.16JAVA CENTER.............	2.38	6.57	1.30	6.57		7.25
13		10.02	5.25	9.02	12.69NORTH JAVA............	3.53	7.07	1.54	7.07		
12		9.59 f	5.10f	8.59f	13.29PERRYS................	.60	7.09 f	1.59f	7.09 f		
10		9.52	5.00	8.52	16.32JOHNSONBURG...........	3.03	7.18	2.19	7.18	●	
8		9.44	4.40	8.44	18.43VARYSBURG.............	2.11	7.24	2.39	7.24		
6		9.38 f	4.15f	8.38f	20.26EARLS................	1.83	7.29 f	2.49f	7.29 f		
3		9.32 f	4.05f	8.32f	22.65SIERKS................	2.39	7.37 f	2.59f	7.37 f		
0		9.20	3.50	8.20	25.91	DEP.ATTICA...........AR.	3.26	7.50	3.14	7.50		

NORTH BOUND TRAINS ARE SUPERIOR TO SOUTH BOUND TRAINS. TRAINS 2, 3, 4 AND 5 RUN DAILY EXCEPT SUNDAY
[Signifies flag stop. TRAINS 101 AND 102 RUN DAILY. TRAINS 6, 7 AND 108 RUN SUNDAYS ONLY.

The October 17, 1916, timetable of the Buffalo, Attica and Arcade Railroad shows two daily-except-Sunday trains in each direction between Arcade and Attica. On Sunday there was one round-trip between Arcade and Attica. At Attica there were convenient train connections to Buffalo plus the East Coast via the Erie Railroad. (Arcade and Attica Railroad collection.)

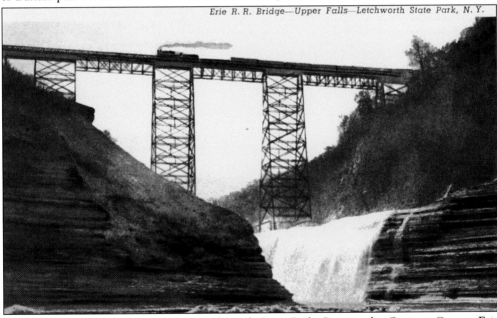

Erie R. R. Bridge—Upper Falls—Letchworth State Park, N. Y.

An Erie Railroad train is traversing Letchworth State Park. Serving the Genesee County Fair at Batavia, the Buffalo, Attica and Arcade Railroad train around 1916 left Arcade at 6:30 a.m. arriving at Attica at 7:50 a.m. where the Erie Railroad train left at 9:18 a.m., arriving at Batavia at 9:40 a.m. The Erie Railroad train left Batavia at 6:07 p.m., arriving at Attica at 6:30 p.m. The Arcade train left Attica at 6:45 p.m.

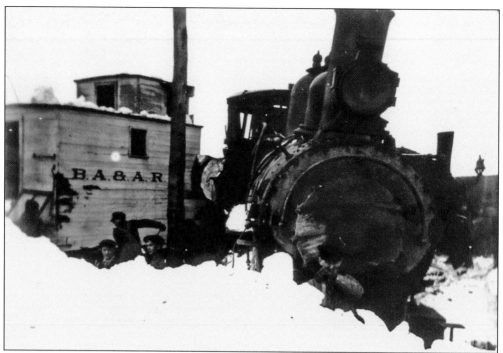

A Buffalo, Attica and Arcade Railroad locomotive is derailed in the snow around 1916. This region was in the snow belt, where mountains of snow and cold temperatures presented a challenge to maintain rail service. It took extra effort to get the locomotive and cars back on track in this environment. (Arcade Historical Society collection.)

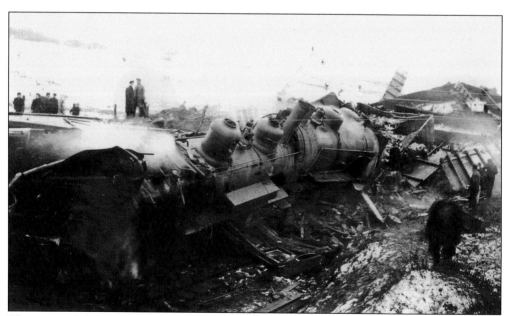

This postcard shows a massive derailment somewhere near Arcade. Cleanup of this scene took a lot of planning and hard work. The picture indicates that a head-on collision occurred. (Arcade town historian collection.)

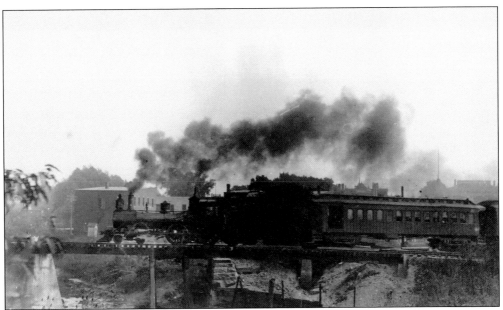

In this classic scene, a Buffalo, Attica and Arcade Railroad train is crossing the trestle over Cattaraugus Creek in Arcade. North of this the line passes a few industrial companies and heads into farming country. This railroad was a short line, which the American Short Line Railroad Association defines as less than 100 miles of main line track. (Arcade town historian collection.)

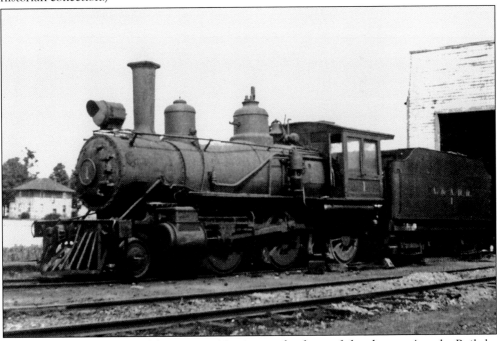

Arcade and Attica Railroad locomotive No. 1 is at the front of the shop at Arcade. Built by Baldwin Locomotive Works in July 1894, it was acquired from the Toronto, Hamilton and Buffalo Railroad on October 1, 1917. The shop structure had a false front, which was gone by 1938, and the locomotive was scrapped by 1940. (Patrick D. Connors collection.)

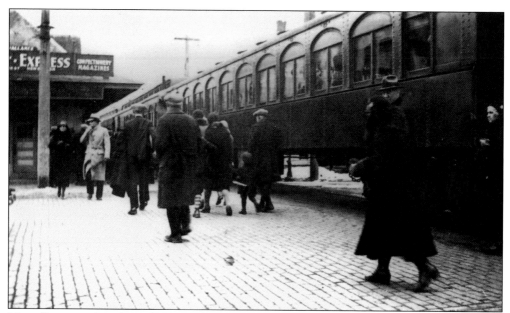

Main Street in Arcade is the scene for the Arcade and Attica Railroad special stockholder's train that brought stockholders along the route from Attica for the meeting around 1940. At its peak around 1916, the railroad passenger train was the main way to travel nationwide. With the train station in the heart of the business district, the downtown area thrived as the railroad brought riders into the commercial area. (Arcade Historical Society collection.)

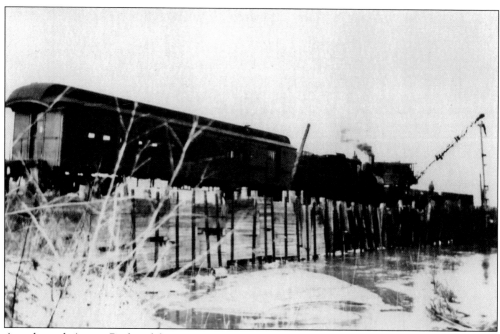

Arcade and Attica Railroad locomotive No. 1, with a 2-6-0 wheel arrangement commonly called a Mogul, and coach No. 301 are on a work train to stabilize the right-of-way south of Attica along the roadway, which is present-day New York State Route 98, on February 10, 1932. This area was prone to washouts. (Patrick D. Connors collection.)

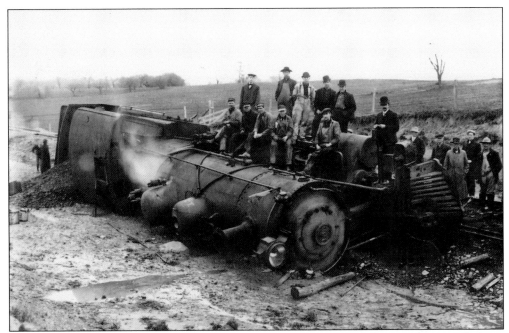

Buffalo and Susquehanna Railroad locomotive No. 135 is derailed along New York State Route 98 in Sandusky, which is south of Arcade, around 1911. The *Arcade Herald* newspaper of July 25, 1991, noted that this locomotive had the distinction of having derailed more than any other engine on the railroad. (Arcade town historian collection.)

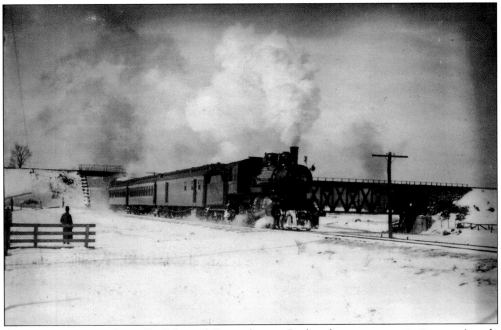

On a snowy winter day, a Buffalo and Susquehanna Railroad passenger train is near Arcade Junction heading southbound toward Wellsville. The February 20, 1916, schedule showed two trains in each direction from Buffalo via Arcade to Wellsville. (Arcade Historical Society collection.)

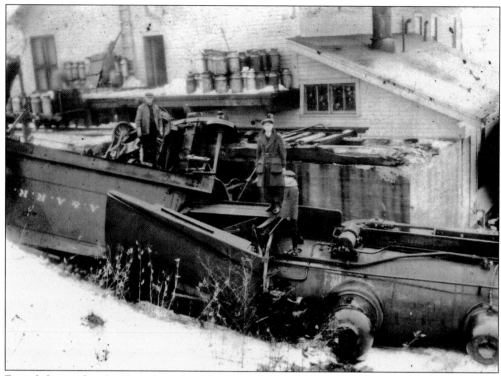

From left to right, Gus Berwanger and Richard I. Cartwright are looking at the derailment on the Arcade and Attica Railroad involving engine No. 1 at Java Center that took place either in 1922 or 1923. Richard I. Cartwright later became president of the Arcade and Attica Railroad. (Arcade Historical Society collection.)

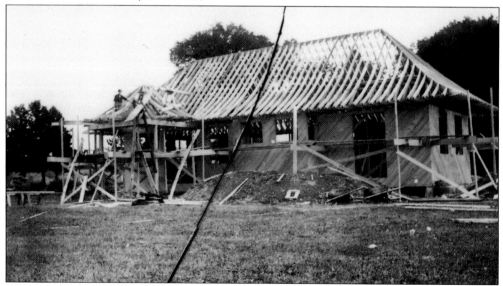

This is the back side of the Buffalo and Susquehanna Railroad station under construction on Park Street in Arcade. This line linked Arcade with Buffalo via Yorkshire, Sardinia, and Springville. It operated south of Arcade via Crystal Lake and Wellsville to Galeton, Pennsylvania. (Arcade Historical Society collection.)

Construction of the Buffalo and Susquehanna Railroad station is nearing completion at Park Street in Arcade. This was the third railroad to serve Arcade. Its line to Buffalo was in competition with the Pennsylvania Railroad. This area was fortunate to have abundant rail service with two different routes from Arcade to Buffalo that operated under all types of weather conditions. (Arcade Historical Society collection.)

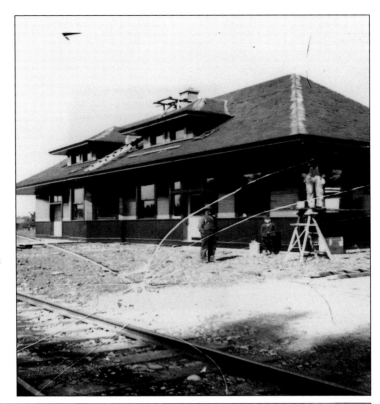

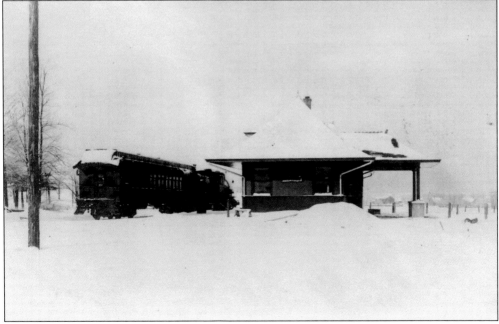

On a cold snowy day, a Buffalo and Susquehanna Railroad passenger train is at the Park Street station in Arcade. After the Buffalo and Susquehanna Railroad ceased operation, the station was later turned 90 degrees and is now a two-family house at 99–101 Park Street. (Arcade Historical Society collection.)

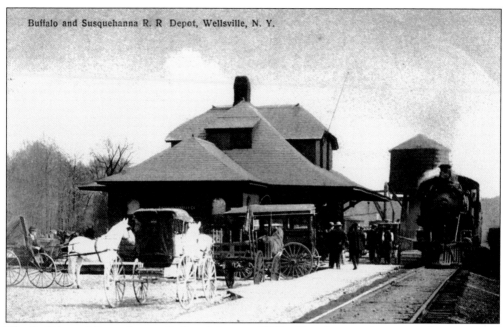

The Buffalo and Susquehanna Railroad depot at Wellsville is busy in this postcard view around 1910. From 1904 until 1913, the Buffalo, Attica and Arcade Railroad was operated as part of the Buffalo and Susquehanna Railroad. On November 17, 1916, the Buffalo and Susquehanna Railroad was reorganized as the Wellsville and Buffalo Railroad. Its abandonment led to the incorporation of the Arcade and Attica Railroad by local interests.

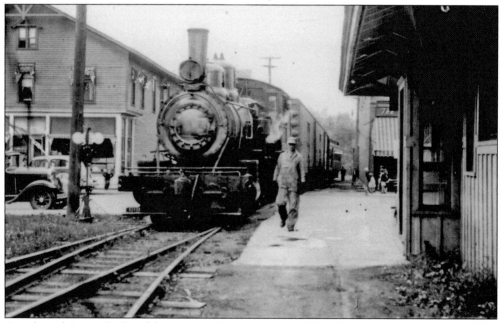

Arcade and Attica Railroad locomotive No. 8 is crossing Main Street in Arcade in the 1930s. This Mogul-type steam locomotive with a 2-6-0 wheel arrangement was built by Brooks Locomotive Works in 1897 (builders plate 2872) for the Reynoldsville and Falls Creek Railroad as No. 4. (Arcade and Attica Railroad collection.)

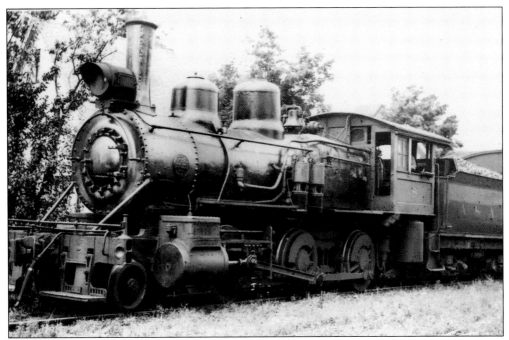

Arcade and Attica Railroad locomotive No. 8, with its 50-inch-diameter driver wheels, is near the downtown Arcade train station on July 30, 1938. It was purchased from the Buffalo, Rochester and Pittsburgh Railroad in November 1929 for $2,500, and was sold during 1943. (Patrick D. Connors collection.)

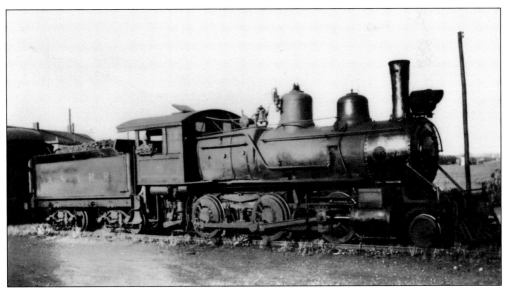

On July 30, 1938, Arcade and Attica Railroad locomotive No. 8 is waiting for the next assignment. The railroad was organized to keep farmers and manufacturers along the line in business. It has done that and has preserved an important rail link for a portion of Wyoming County. (Arcade and Attica Railroad collection.)

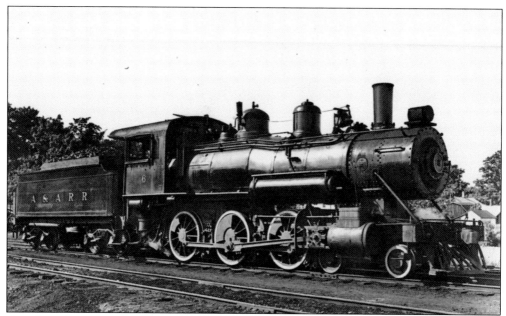

Arcade and Attica Railroad steam locomotive No. 6 is at the Arcade yard on August 1938. Baldwin Locomotive Works built this locomotive in October 1907 for the Alabama and Vicksburg Railroad as No. 451. It was acquired from the Illinois Central Railroad for $5,000 in December 1926. With a 4-6-0 wheel arrangement, this was called a 10-wheeler with a two-axle leading truck and three driving axles. (Harold K. Vollrath collection.)

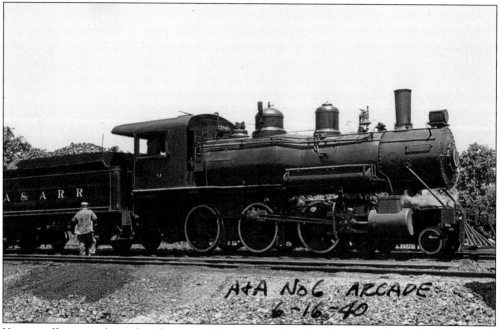

Known affectionately as the "fire starter" because of the fires that would start along the track as it passed by, Arcade and Attica Railroad steam locomotive No. 6 is in front of the Arcade shop pointing south on June 16, 1940. This locomotive was used for an excursion of the Railroad Enthusiasts, Inc., New York Division. (Photograph by Vic Neal; Patrick D. Connors collection.)

26

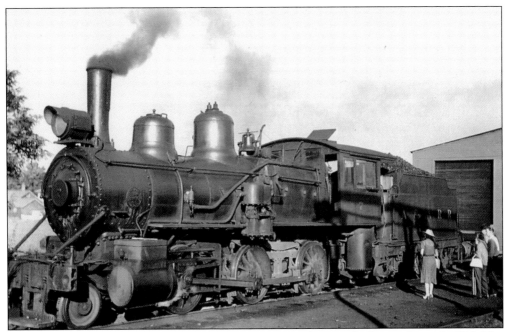

Arcade and Attica Railroad steam locomotive No. 7 is at the Arcade shop on June 12, 1938. The locomotive tender was not the original tender for No. 7. This tender was used behind several different locomotives perhaps because of its increased capacity. The locomotive was used on an excursion using coaches No. 301, No. 302, and two open gondola cars. (Photograph by Vic Neal; Patrick D. Connors collection.)

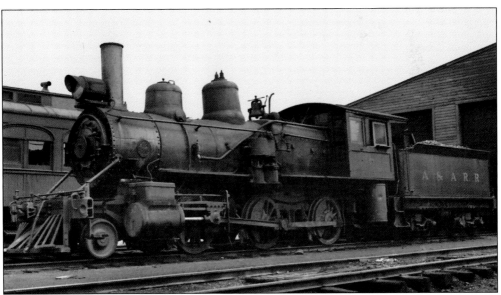

Arcade and Attica Railroad steam locomotive No. 7 is at the Arcade engine house on May 1939. Brooks Locomotive Works built this locomotive in 1900 with 50-inch-diameter driver wheels for the Reynoldsville and Falls Creek Railroad as No. 5. It was acquired during 1929 at a cost of $2,500. (Harold K. Vollrath collection.)

Waiting for the next assignment, Arcade and Attica Railroad steam locomotive No. 7 is at the Arcade engine house during 1939. It was sold on April 25, 1942, to the Railway Accessories Company for $1,750 plus the cost of certain repairs that were made by the Arcade and Attica Railroad. (Arcade and Attica Railroad collection.)

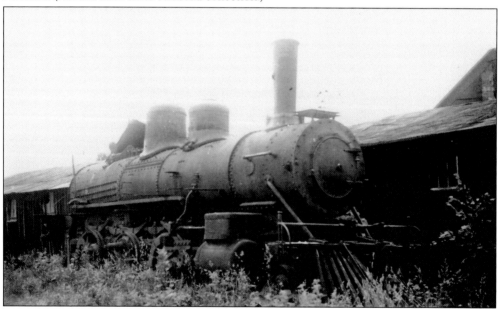

Ten wheeler–type locomotive No. 5 with a 4-6-0 wheel arrangement is on the scrap track at Arcade during 1939. This locomotive was built by Pittsburgh Locomotive and Car Works in November 1892 for the Louisville, St. Louis and Texas Railroad as No. 17. It was acquired on October 10, 1925, for $6,500 from the Georgia Car and Locomotive Company. (Arcade and Attica Railroad collection.)

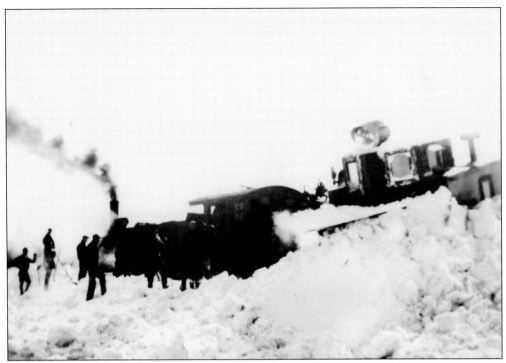

On March 26, 1940, an Arcade and Attica Railroad train has derailed following an Easter blizzard just north of Monkey Run Creek, which is between Arcade and Curriers. Huge snowdrifts occurred in many places along the line, which contributed to derailments. Working in snow conditions added to the cleanup task. (Photograph by Harry S. Douglass; Arcade town historian collection.)

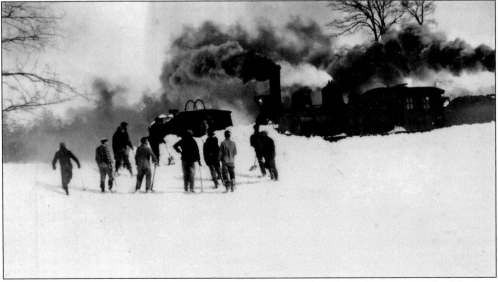

Southwestern New York is in the snow belt as evidenced by this blizzard in 1941 north of Curriers with a derailment on the Arcade and Attica Railroad. The length of line from Arcade Junction to Attica was 28 miles, which at times was a challenge to keep open during the winter snow season. (Photograph by Harry S. Douglass; Arcade town historian collection.)

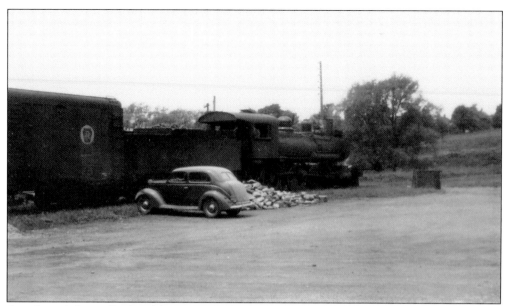

Arcade and Attica Railroad locomotive No. 6 is powering a freight train in June 1946. The Pennsylvania Railroad boxcar behind the tender passing a vintage automobile was once a common sight in this nation. While the Pennsylvania Railroad survived hard economic times of the 1930s, later declines in passenger and freight business caused massive changes in the railroad industry. (Photograph by Harry S. Douglass; Arcade town historian collection.)

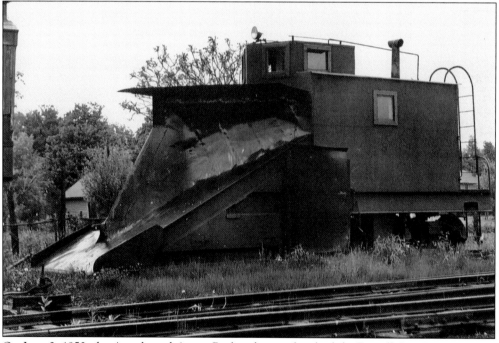

On June 2, 1950, the Arcade and Attica Railroad snowplow built by Russell Car Company is at the shop in Arcade. This was an original wooden snowplow acquired from the Buffalo, Attica and Arcade Railroad. It was converted to a steel body and plow by the Arcade and Attica Railroad shop crew around 1932. (Patrick D. Connors collection.)

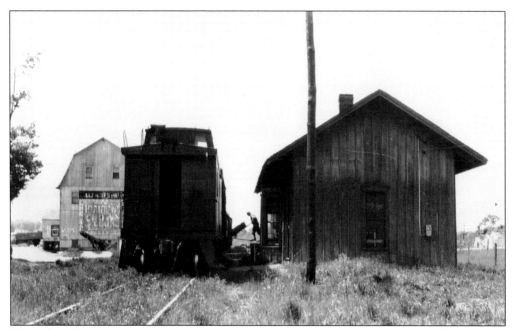

North Java looking south is the scene for Arcade and Attica Railroad caboose No. 304 on June 2, 1950. Express packages or less than carload freight were apparently being loaded. The depot was located where the parking lot of the Reisdorf Brothers Feed Mill is today. The mill would be to the right of the picture. (Patrick D. Connors collection.)

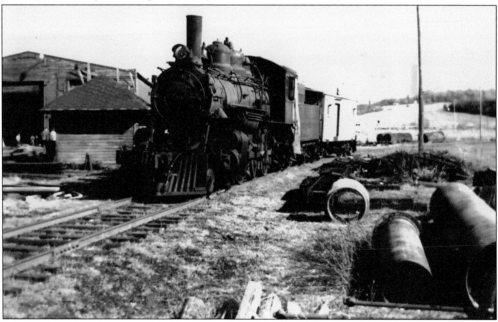

Steam engine No. 14 is at Arcade with caboose No. 304 in the rear after April 1963. It was still lettered Escanaba and Lake Superior Railroad on the tender, and the winter canvas tarps were hanging on the cab. Maintenance of way materials on the ground on the right side of the picture were south of the sand house at Arcade shops. (Photograph by Richard F. Nashold; Patrick D. Connors collection.)

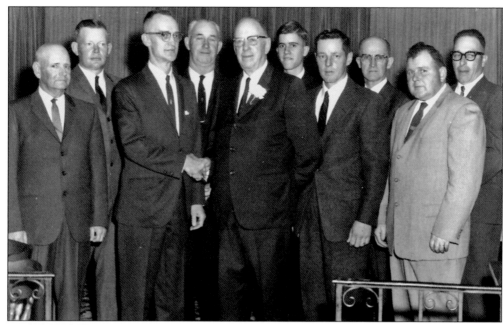

In this Saturday, April 2, 1966, photograph, honoring Richard I. Cartwright, president of the Arcade and Attica Railroad, on his retirement are, from left to right, Howard Hopkins, Cecil A. Lester, Gerald G. Hutton, Emmett King, Richard I. Cartwright, Edward A. Lewis, Thomas Gainey, F. M. Rieppel, Nelson Cornell, and Lyle Sherlock. Cartwright had served the railroad and its predecessor company for 54 years. (Photograph by John C. Vought; Arcade town historian collection.)

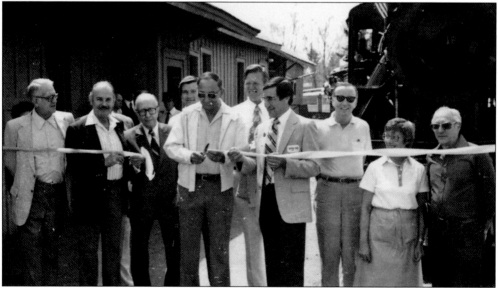

The 100th anniversary of the first train to reach Arcade on the Tonawanda Valley Railroad was commemorated on May 24, 1981, at this ribbon-cutting ceremony in front of locomotive No. 18. From left to right are Robert Bentley, Frank Conroy Jr., Anson Sherman, Dick Conley, John Yansick (with the scissors to cut the ribbon), Vincent George, Stan Roberts, James Hurley, Ruth Davis, and Milton Hesslein. (Arcade Historical Society collection.)

A new Arcade and Attica Railroad trestle is being constructed over Cattaraugus Creek at Arcade, north of the downtown area, in this November 1980 scene looking north. The bridge is west of the point where Clear Creek flows into Cattaraugus Creek. The structure was designed to handle the heavy rainfall that has sometimes occurred late spring or early summer as well as snowmelt. (Photograph by Jeffrey C. Mason; Arcade town historian collection.)

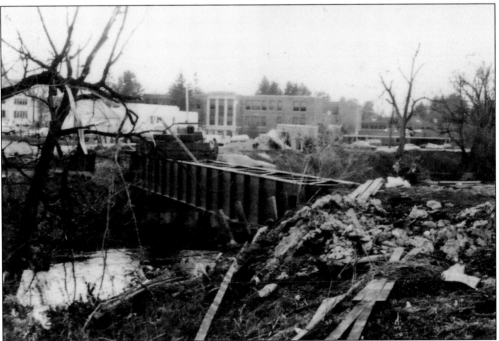

This view looks southwest of the new Arcade and Attica Railroad trestle that is under construction over Cattaraugus Creek on November 1980. The new bridge was designed to handle heavier freight cars. (Photograph by Jeffrey C. Mason; Arcade town historian collection.)

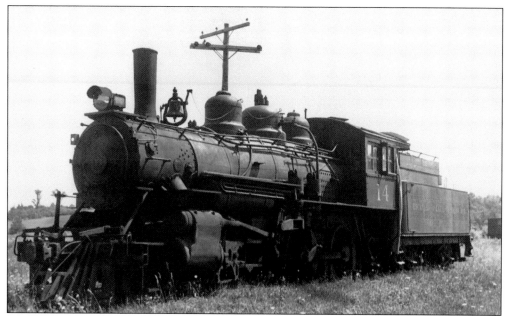

On April 22, 1963, locomotive No. 14 is still in the Escanaba and Lake Superior Railroad paint scheme and is located on the wye at Arcade awaiting inspection and painting for excursion service by the Arcade and Attica Railroad. This locomotive was last utilized to make steam for melting switches on the Escanaba and Lake Superior Railroad before it had been purchased by the Arcade and Attica Railroad. (Patrick D. Connors collection.)

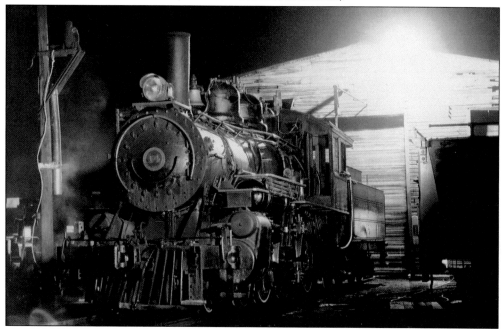

Arcade and Attica Railroad locomotive No. 14 is on the center track at the Arcade shop. Baldwin Locomotive Works built the locomotive in 1917 with a 4-6-0 wheel arrangement and 58-inch-diameter driver wheels. This locomotive operated on the Arcade and Attica Railroad from 1964 to 1978 and from 1982 to 1988. (Photograph by Ken Kraemer.)

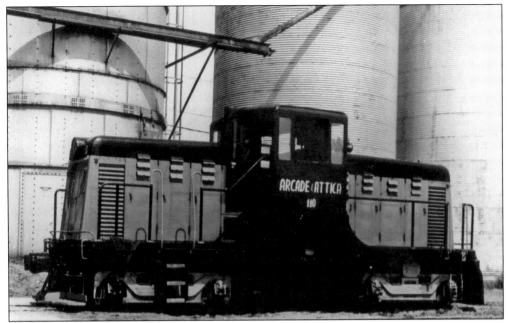

Diesel locomotive No. 110 is at North Java at the Reisdorf Brothers Feed Mill. This was an early production, 44-ton locomotive built by General Electric Company. The rear step is midway on the hood, and not on the corner as on more modern locomotives. The corner step was added by the Arcade and Attica Railroad for Interstate Commerce Commission compliance. (Patrick D. Connors collection.)

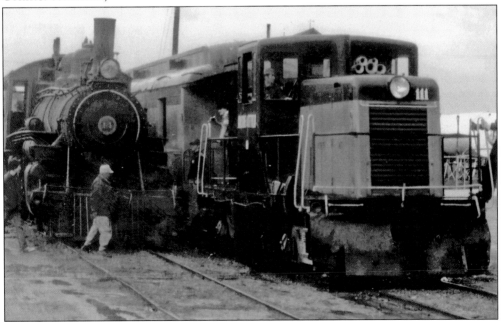

A special mixed train, arriving at North Java on June 1982, is operating on the entire Arcade and Attica Railroad line for the Western New York Railroad Historical Society. Engineer Manley Hakes is crossing in front of locomotive No. 14, heading over to diesel locomotive No. 111. (Photograph by Ken Kraemer.)

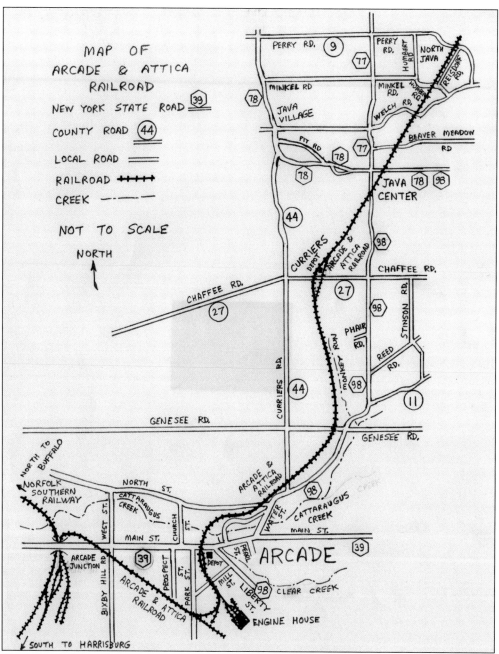

MAP OF
ARCADE & ATTICA
RAILROAD

NEW YORK STATE ROAD ⑨

COUNTY ROAD ㊹

LOCAL ROAD ═══

RAILROAD ┼┼┼┼

CREEK ─ ─ ─ ─

NOT TO SCALE

NORTH ↑

The current line of the Arcade and Attica Railroad with adjacent roads is shown in this map. This line interchanged with the Pennsylvania Railroad at Arcade, which later became Penn Central Transportation Company, Consolidated Rail Corporation (Conrail), and today Norfolk Southern Railway leases that trackage to the Buffalo and Pittsburgh Railroad. Passenger excursion service operates from the depot on Main Street in Arcade to the depot at Curriers. Freight service operates north to North Java. Rail enthusiasts flock to the railroad from many states and Canada excited by the sounds of the steam locomotive and the clickety-clack of the train passing through the beautiful countryside.

Two

PASSENGER AND
EXCURSION SERVICE

The three-foot narrow-gauge Tonawanda Valley Railroad began passenger service from Attica to Curriers on September 27, 1880. Following the extension of the railroad south to Cuba, New York, under the Tonawanda Valley and Cuba Railroad, passenger service was established from Attica via Arcade and Sandusky to Cuba. At each end of the line, connections could be made with the Erie Railroad. The line from Sandusky to Cuba made its last run on October 30, 1886. On October 13, 1894, the Buffalo, Attica and Arcade Railroad was organized and the line was converted to four feet eight and a half inches standard gauge. Fearing the loss of railroad service, local interests incorporated the Arcade and Attica Railroad and purchased the Buffalo, Attica and Arcade Railroad. Passenger ridership declined from 11,312 in 1926, to 6,081 in 1927, and 2,374 in 1928 as more people used automobiles for their travel needs. Permission was received to discontinue railroad passenger service effective August 1, 1951. With a decline in freight business in the early 1960s, it was decided to locate a steam locomotive and try excursion service. Following formal dedication ceremonies on Main Street in Arcade on August 4, 1962, attended by assemblyman Harold Peet; supervisor C. G. Knight; Mayor John Bailey; Richard I. Cartwright, president of the Arcade and Attica Railroad; and Leonard Connelly, president of the Arcade Chamber of Commerce, steam locomotive passenger excursion service was started with locomotive No. 18, operated by Bud King and his brother Donald King alternating at the throttle. Train conductors were Howard Hopkins and Cecil A. Lester handling passengers on two previous Delaware, Lackawanna and Western Railroad passenger cars painted orange with a black roof and black lettering. On September 2, 1962, a third coach was added to the train followed by a fourth passenger car on September 30, 1962. A second steam locomotive, No. 14, went into passenger service on August 15, 1964. The railroad passenger service has continued over the last 47 years from Memorial Day in May through October, plus some special theme events at other times. Over 20 local volunteers and the staff of the ABC Television program *Extreme Makeover: Home Edition* worked to make the railroad handicapped accessible, and a special train was operated on September 18, 2008, to commemorate the completion of that project. With a hardworking productive workforce, the railroad has preserved history for the next generation.

The *Official Guide of the Railways* for August 1936 shows one daily northbound train on the Arcade and Attica Railroad leaving Arcade at 6:00 a.m. and arriving at Attica at 7:45 a.m. Southbound, Monday through Saturday, the train left Attica at 9:30 a.m. and arrived at Arcade at 11:15 a.m. On Sunday, the train left Attica at 8:15 a.m. and arrived at Arcade at 10:00 a.m.

The *Official Guide of the Railways* for August 1936 shows the Pennsylvania Railroad with two northbound trains stopping at Arcade for Buffalo and two southbound trains from Buffalo stopping at Arcade. However, the Pennsylvania Greyhound Lines, Inc., operated three southbound trips from Buffalo stopping at Arcade, and two northbound trips stopping at Arcade for Buffalo. Hence, Arcade had rail and bus links to the outside world.

Erie Railroad

SHIP AND TRAVEL FAST — ERIE SERVICE

EASTERN STANDARD TIME.

Table 15. BUFFALO-JAMESTOWN.

519	517	515	513	Mls	June 14, 1936.	514	516	518	520	
	#		#		(Eastern time.)	#		#		
P M	P M	P M	A M		(Lehigh Valley Terminal.)	A M	A M	P M	P M	
*505	†420	†1250	*805	o	lve..+ Buffalo δ..arr.	702	1050	255	705	
522	†459	†1248	824	5.6Blasdell....δ	543	1031	237	648	
533	450	100	836	11.7Hamburg...δ	633	1020	227	638	
f536	f453	f103	—	12.5	..Water Valley..δ	628	—	—	—	
f540	458	f107	f841	15.0	..Eden Valley..δ	623	f1013	f221	f631	
545	505	112	846	17.3	..Eden Center..δ	618	1008	215	626	
552	510	119	853	21.6	..North Collins..δ	610	1000	209	618	
558	517	126	900	25.6Lawton's...δ	603	952	f202	611	
604	523	132	906	28.6Collins....δ	556	945	156	604	
611	530	140	914	31.6	...Gowanda...δ	550	938	1150	554	
625	P M	P M	930	36.0Dayton....δ	A M	924	P M	540	
—	—	—	—	38.0	...Markham's...	—	—	—	—	
635			942	41.5	..South Dayton..δ		913		528	
645			952	46.5	..Cherry Creek..δ		905		519	
651			1000	50.8	..Conewango..δ		858		512	
—			1013	58.5Kennedy...δ		846		459	
711			1023	64.0	...Falconer...δ		838		451	
717			1030	67.5	+..Jamestown..δ		*832		*445	
P M			A M		ARRIVE] [LEAVE		A M		P M	

Holidays in the above table refer to the observance of New Year's Day, Memorial Day, Independence Day (4th of July), Labor Day, Thanksgiving Day and Christmas Day.

Table 16—LACKAWAXEN-HONESDALE.

	9-271	Mls	June 14, 1936.	270-28	
			(Eastern time.)		
			lve...New York...arr.		
	*930 A M		+..West 23d Street..	605 P M	
	940 A M		+..Chambers Street..	554 P M	
	1000 A M		+..Jersey City..	540 P M	
	Mixed.		Eastern time.	Mixed.	
	*255 P M	o	lve..Lackawaxen δ arr.	215 P M	
	302 »	4.1	...Rowlands...δ	205 »	
	309 »	7.5	..Glen Eyre..δ	155 »	
	f	9.2	..Shimers Rock Cut..	f	
	317 »	11.7	...Kimbles...δ	145 »	
	f324 »	15.1	..Wellwood Avenue..δ	f135 »	
	332 »	15.7	...Hawley...δ	132 »	
	341 »	19.5	..White Mills..δ	121 »	
	f350 »	23.8	..East Honesdale..	113 »	
	355 P M	24.6	arr..Honesdale δ..lve.	*1259 P M	

Table 19—MEADVILLE-OIL CITY. (Via Welsh Bus Line.)

	Bus.	Bus.	Bus.	Bus.	Mls	June 14, 1936.	Bus.	Bus.	Bus.	Bus.	
						(Eastern time.)					
	P M	P M	A M	A M		LEAVE] [ARRIVE	A M	A M	P M	P M	
	*815	*725	*850	*700	o	...Meadville...	635	820	655	850	
	830	740	905	715	6.1Shaws....	625	810	645	840	
	840	750	915	725	10.7	..Cochranton..	615	800	635	830	
	848	758	923	733	14.8	...Carlton...	607	752	627	822	
	18.8Utica....	
	1008	818	943	753	24.0	..Sugar Creek..	547	733	607	802	
	1020	830	955	805	27.7	...Franklin...	535	720	555	750	
	1030	840	1005	815	33.0Reno....	525	715	545	740	
	1040	850	1015	825	36.3	...Oil City...	*515	*700	*530	725	
	A M	A M	A M	A M		ARRIVE] [LEAVE	A M	A M	P M	P M	

Note—Tickets sold and baggage checked through to Franklin and Oil City.

Table 22—CARBONDALE LINE.

	Mls	STATIONS.	
		(Eastern time.)	
		lve...New York...arr.	
		+..West 23d Street..	
		+..Chambers Street..	
		LVE.] Eastern time. [ARR.	
	o	+..Susquehanna..δ	
	1.7	...Lanesboro...δ	
	4.2Brandt....δ	
	5.3	..Stevens' Point..	
	10.4	...Starrucca...δ	
	14.2	..Thompson..δ	
	19.0Ararat....δ	
	22.4	...Burnwood...δ	
	25.7	..Herrick Centre..δ	
	27.5	...Uniondale...δ	
	32.7	+..Forest City..δ	
	39.0	...Carbondale..δ	
		ARRIVE] (E. T.) [LEAVE	
		..Scranton (D. & H.)..	
		ARRIVE] [LEAVE	

Table 18. NEW YORK-BUFFALO.

	7- 477	5	Mls	June 14, 1936.	2	472	480	6	
				(Eastern time.)					
A M	P M	P M	o	lve.....New York....arr.	P M			A M	
*805	*1055	*700		+....West 23d Street....	745			805	
810	1130	730		+...Chambers Street...	734			754	
830	1145	745	1.0	+....Jersey City....	720			740	
P M	A M	A M		[LEAVE] [ARRIVE]	P M			A M	
*201	*542	*122	215.1	+....Binghamton....	143			157	
214	553	—	223.7	+......Endicott.....	132			147	
251	637	—	256.2	+......Waverly.....	1251			112	
317	712	235	273.8	+......Elmira......	1230			1250	
341	744	300	291.1	+......Corning.....	1207			1207	
433	845	351	332.3	+..Hornell...lve.	1114		P M	1131	
448	900	430	332.3	lve....Hornell....arr.	1105		750	1120	
—	908	428	338.0	+......Arkport.....	1055		759	—	
—	—	—	Burns......	—		733	—	
—	920	438	344.8	+....Canaseraga....	1040		726	1101	
—	—	—	347.2Garwoods.....	—		721	—	
—	—	—	349.2Swains......	—		717	—	
—	937	—	356.4	+......Dalton......	—		707	—	
—	942			...Washington Hunt...	—		702	—	
—	—			{+Portage.... }	—			—	
—	949		362.6	{...Letchworth Park}..	—		654	—	
530	958	512	366.5	+......Castile.....	1012		645	1029	
535	1004	517	369.4	+...Silver Springs...	1006		638	1025	
—	—	—	Rock Glen....	—		—	—	
547	1018	529	376.6	+......Warsaw.....	955		624	1011	
—	—	—	382.4Dale......	—		614	—	
—	1032	—	396.7Linden.....	—		P M	—	
611	1045	555	393.7Attica......	930		130	555 948	
—	—	602	397.6Griswolds....	—		122	548	
—	1056	607	399.9	..Darien Center...	—		117	542	
620	1105	615	405.5	+......Alden......	910		105	530 927	
—	—	620	408.3Marilla.....	—		100	523	
—	—	623	410.3	...Town Line....	—		1256	518	
—	1117	630	414.1	...Lancaster.....	859		1249	510	
—	—	633	415.6Depew.....	—		1245	506	
—	—	643	422.2	...East Buffalo...	—		1235	454	
658	1149	655	424.9	+{Lehigh Valley Term. }{Main and Scott Streets}	*840		1225	*445 +900	
P M	A M	A M		arr....Buffalo....lve.	A M		P M	P M P M	

✻ Will not run New Year's Day, Lincoln's Birthday, Washington's Birthday, Memorial Day, Independence Day, Labor Day, Thanksgiving Day and Christmas. + Coupon stations; δ Telegraph stations.

Table 24—ELMIRA-HOYTVILLE.

		Mls	STATIONS.		
		o	lve..+ Elmira δ.....arr.		
		7.2	...Pine City...		
		8.8	..Seeley Creek..δ		
		12.0	...Millerton...δ		
		14.9	..Trowbridge..		
		17.4	..Jackson Summit..δ		
		23.4	..Tioga Junction..δ		
		26.8	..Lawrenceville..δ		
		23.4	..Tioga Junction..δ		
		27.2Tioga.....		
		29.9	...Mill Creek...		
	Freight Service only.	33.0	..Lamb's Creek..δ		Freight Service only.
		35.8	...Mansfield...δ		
		37.7	..Canoe Camp..		
		40.7	..Covington..δ		
		45.4	..Blossburg..δ		
		48.7	arr...Morris Run..lve.		
		45.4	...Blossburg...δ		
		49.3Arnot.....		
		54.4Landrus....		
		60.1Morris....		
		61.0	...Hoytville...		
			ARRIVE] [LEAVE		

Table 25—MIDDLETOWN-PINE BUSH.

61	Bus.	Mls	June 14, 1936.	58	2	
✻PM			lve..New York..arr.	A M	✻PM	
†1230			+..West 23d Street..	950	745	
1245	✻		+..Chambers Street..	939	734	
105			+..Jersey City..	925	720	
Bus.	A M		LEAVE] [ARRIVE	Bus.	Bus.	
†400	†615	o	+..Middletown..	700	405	
415	630	5.3	..Circleville..	635	345	
420	635	7.7	...Bullville...	630	340	
425	640	10.2	..Thompson Ridge..	625	335	
435	650	13.5	...Pine Bush...	†615	†330	
P M	A M		ARRIVE] [LEAVE	A M	P M	

Note—Tickets sold and baggage checked through to Circleville, Bullville, Thompson Ridge and Pine Bush.

*Daily; †daily, except Sunday; §Sunday only; δstops to discharge passengers from Buffalo and on signal to receive passengers; k Saturday only; q no agent on duty—no baggage handled on Trains 5 or 6 to or from Castile; y stops to leave from Hornell and east and on signal to receive passengers; z stops to discharge passengers. ‡ Will not run holidays. δ Stops to discharge passengers from New York. ■ Stops to discharge passengers from Buffalo, Jamestown, and west.

The *Official Guide of the Railways* for August 1936 shows the Erie Railroad with three daily trains from New York City via Attica to Buffalo and four trains from Buffalo to Attica with two trains continuing to New York City, and one train ending at Hornell. The Arcade and Attica Railroad connected with the Erie Railroad at Attica, which gave communities from Arcade to Attica a link to the nationwide passenger railroad network. In 1936, there still was considerable local passenger service on the intersecting branch railroad lines.

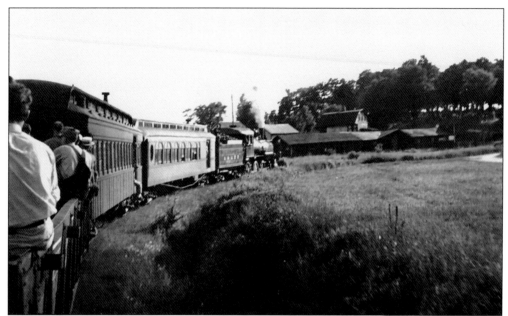

On June 16, 1940, Arcade and Attica Railroad locomotive No. 6 is on the wye at Arcade on an excursion for the Railroad Enthusiasts, Inc., New York Division. This was entering the original Buffalo and Susquehanna Railroad main line at Park Street in Arcade. The Arcade Rural Cemetery was on the hill ahead of the train. (Photograph by Roland Gillis; Patrick D. Connors collection.)

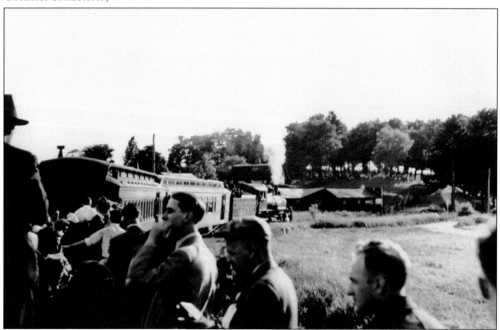

The excursion train for the Railroad Enthusiasts, Inc., New York Division, is on the wye at Arcade on June 16, 1940. The train pulled by locomotive No. 6 consisted of Arcade and Attica Railroad coaches No. 301 and No. 302, plus two Pennsylvania Railroad gondola cars. (Chris Lester collection.)

The Railroad Enthusiasts, Inc., New York Division excursion is at the Arcade and Attica Railroad interchange with the Pennsylvania Railroad at Arcade Junction on June 16, 1940. This is now the location of the Blue Seal Feed Mill, and the interchange is with the Norfolk Southern Railway, which leases the tracks to the Buffalo and Pittsburgh Railroad. (Chris Lester collection.)

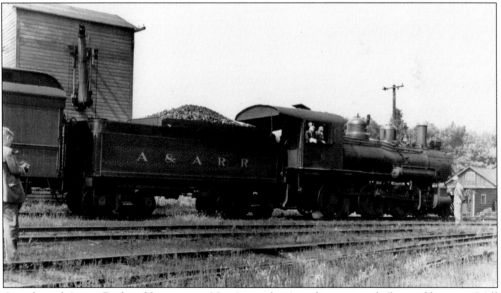

Arcade and Attica Railroad locomotive No. 6 is at the Arcade water tank (located between Mill Street and the engine house), getting ready for the northbound run to Attica for the June 16, 1940, excursion train for the Railroad Enthusiasts, Inc., New York Division. The water tank, known as the sand house, was built in 1918 and was demolished in the spring of 2008. (Patrick D. Connors collection.)

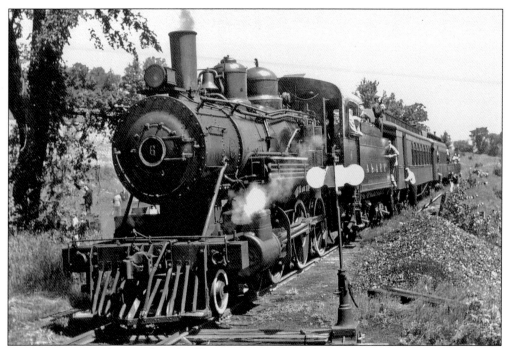

Excursionists are riding in the cab of locomotive No. 6 in this scene probably north of Curriers on June 16, 1940. The Arcade and Attica Railroad allowed passengers on this Railroad Enthusiasts, Inc., New York Division excursion train to have a fun experience. Students of transportation were all around this train at the photograph stop. (Photograph by Vic Neal; Patrick D. Connors collection.)

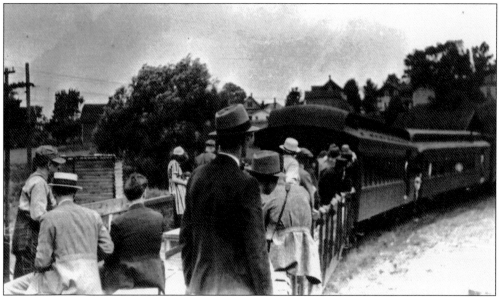

The Railroad Enthusiasts, Inc., New York Division excursion train is leaving Arcade northbound on the Arcade and Attica Railroad and is about to cross the bridge over Cattaraugus Creek with the houses on the hill of North Street in view on June 16, 1940. It is interesting to note the formal attire of the passengers on the gondola car. (Patrick D. Connors collection.)

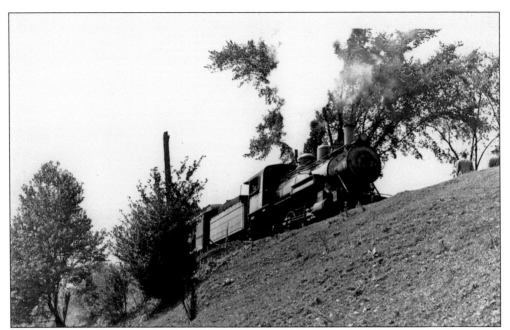

Arcade and Attica Railroad locomotive No. 6 is heading the Railroad Enthusiasts, Inc., New York Division excursion north of Curriers on June 16, 1940. The Arcade and Attica Railroad has always been known by rail enthusiasts to be an excursion-friendly railroad. Railroad clubs chartered special trains as early as 1938. (Patrick D. Connors collection.)

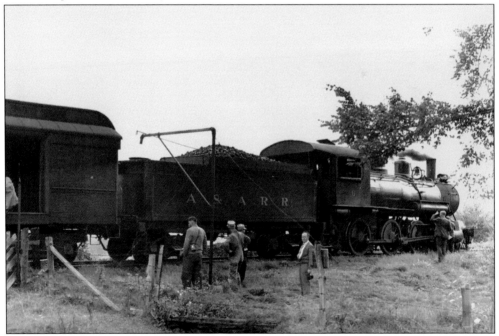

On June 16, 1940, locomotive No. 6 is taking on water at Johnsonburg from a spring-fed pipe on the Railroad Enthusiasts, Inc., New York Division excursion over the Arcade and Attica Railroad. At every stop, train enthusiasts scrambled off and on the train to photograph and record this historic railroad. (Patrick D. Connors collection.)

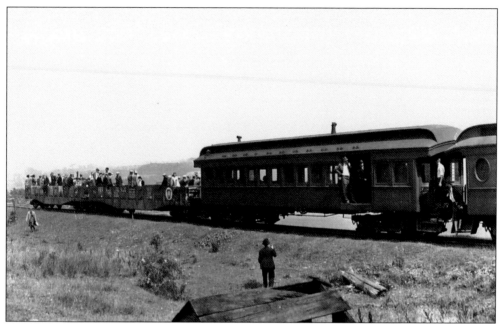

Two gondola cars borrowed from the Pennsylvania Railroad and two vintage Arcade and Attica Railroad passenger coaches are in this view of the train believed to be south of North Java depot on this Railroad Enthusiasts, Inc., New York Division excursion on June 16, 1940. (Patrick D. Connors collection.)

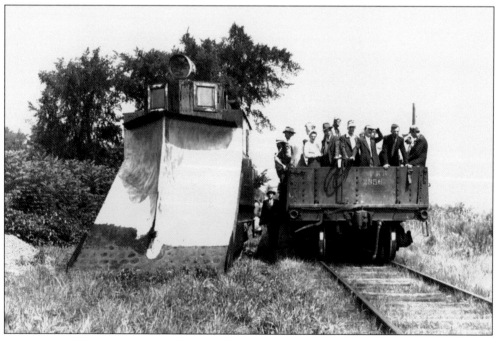

On June 16, 1940, the rear of the Railroad Enthusiasts, Inc., New York Division excursion train has posed next to the snowplow built by Russell Car Company at Sierks (just a road crossing) south of Attica. Two open gondola cars borrowed from the Pennsylvania Railroad were popular on this train. (Patrick D. Connors collection.)

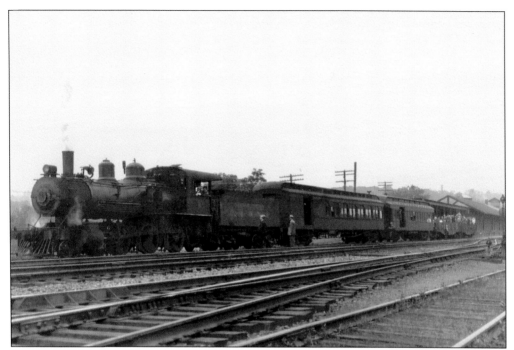

The Railroad Enthusiasts, Inc., New York Division excursion train powered by Arcade and Attica Railroad locomotive No. 6 is at the Attica station on June 16, 1940. This was an interchange point with the Erie Railroad. Both railroads played an important role in the growth of the region. (Patrick D. Connors collection.)

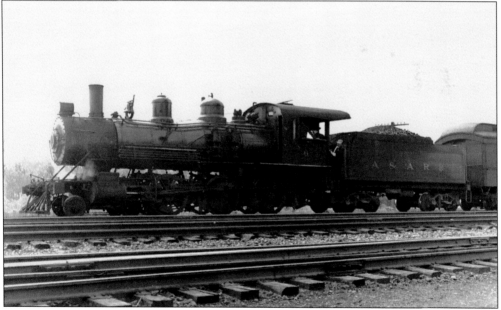

Arcade and Attica Railroad locomotive No. 6 is at Attica station on June 16, 1940, on the Railroad Enthusiasts, Inc., New York Division excursion. This was a well-attended event because it provided a great way to ride, photograph, and experience a unique rural short-line railroad. (Patrick D. Connors collection.)

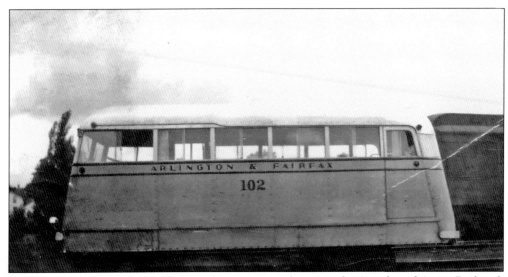

Rubber-tired and steel-wheeled "auto-railer" No. 102 is shown on the Arcade and Attica Railroad. This was one of three cars purchased from the Arlington and Fairfax Railroad in Virginia. It arrived at Arcade in February 1941 with the ability to operate on railroad tracks via four steel-flanged wheels or using its pneumatic tires to operate on a roadway. (Arcade and Attica Railroad collection.)

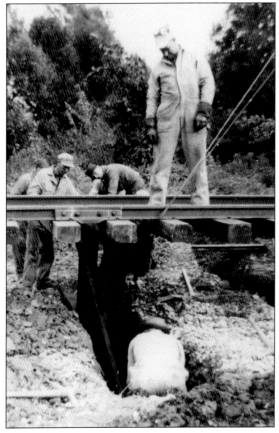

Arcade and Attica Railroad employee Donald King is standing on the track at a washout on the railroad. Flooding caused by heavy rain and beaver dams was an ongoing challenge to the track structure that required prompt attention. Train crews kept a sharp lookout for any sign of beaver dams that could cause flooding. (Arcade and Attica Railroad collection.)

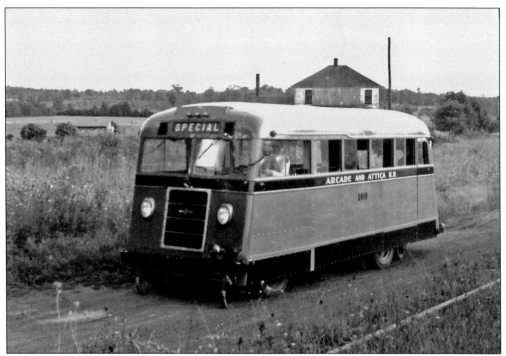

Evans Auto Railer No. 109 is operating off rail for the Arcade and Attica Railroad near Attica. It was equipped with the hi-rail gear. This vehicle replaced the mixed passenger train for the few remaining passengers carried by the railroad. The goal was to have a more effective way to handle passenger traffic. It was eventually sold. (Patrick D. Connors collection.)

On September 7, 1968, New York, Ontario and Western Railroad car No. 30, the *Warwick*, is on the coal track in the municipal parking lot behind the downtown business district for the summer season. This siding served an old coal mill and the Village of Arcade Municipal Electric generating plant. In the winter, the car was moved to the shop area for winter storage. (Harold K. Volrath collection.)

New York, Philadelphia, Washington and Baltimore and Buffalo

SLEEPING, PARLOR AND DINING CARS
(Coaches on all trains)

Miles	(Eastern Standard Time) STATIONS	991 Week-days H	581-575 Daily	45-571 Daily	Miles	(Eastern Standard Time) STATIONS	570 Daily	990 Week-days H	574-604 Daily	
		AM	PM	AM			AM	PM	PM	
.0	Lv New York, {Penna. Sta.	z 6.30	y 8.00			Lv Suspension Bridge, N.Y.(N Y.C.)	† 7.15	12 10	7.55	
	N. Y. {Hudson Ter.	6.18	7.45			" Niagara Falls, N. Y.	7.25	12.20	8.17	
58.1	" Trenton, N. J.	7.33	9.05			Ar Buffalo, N. Y.	8.24	1.20	9.25	
	Philadelphia, Pa.									
91.4	Ar Penna. Sta. (30th St.)	8.10				Lv Toronto, Ont. (C. P. Ry.)			6.05	
	" Broad St. Station					Lv Hamilton, Ont. (T. H. & B.)			7.05	
						Ar Buffalo, N. Y. (M. C.)			3.20	
.0	Lv Atlantic City, N. J.		6.35	† 7.30						
	Philadelphia, Pa.				.0	Lv Buffalo, {Central Terminal	8.45	4.50	10.00	
63.8	Ar Penna. Sta. (30th St.)		7.59	† 8.55		N. Y. {Exchange St. Sta.		5.30		
	" Broad St. Station		8 05	† 9.00	1.5	" Lord Street, N. Y.		5.39		
					6.7	" Ebeneser, N. Y.		5.46		
	Philadelphia, Pa.				10.5	" Spring Brook, N. Y.		5.52		
91.4	Lv Broad St. Station		8.20	9.40	12.9	" Elma, N. Y.		5.56		
	" Penna. Sta. (30th St.)		8.25	9.45	14.7	" Jamison Road, N. Y.		6.00		
111.4	" Paoli, Pa.		8.57	10.11	17.2	" East Aurora, N. Y.	9.18	6.05	10.32	
159.3	" Lancaster, Pa.		10.10	11.00	19.6	" Blakeley, N. Y.		6.10		
194.6	Ar Harrisburg, Pa.		10.49	11.36	22.0	" South Wales, N. Y.		6.15		
					26.7	" Holland, N. Y.		6.22		
.0	Lv Washington, D. C.		8 10	8.10	30.3	" Protection, N. Y.		6.28		
40.1	" Baltimore, Md.(Pa.Sta.)		8 57	9.03	32.9	" Chaffee, N. Y.		6.34		
96.3	" York, Pa.		10.26	10.39	35.8	" Arcade, N. Y.	f 9.44	6.42		
123.4	Ar Harrisburg, Pa.		11.10	11.25	38.9	" Delevan, N. Y.		6.47		
					44.5	" Machias, N. Y.	9.57	6.53		
.0	Lv Harrisburg, Pa.	11.30	11.50		49.7	" Franklinville, N. Y.	10.05	7.12	†11.17	
53.4	" Sunbury, Pa.	12.46			57.2	" Ischua, N. Y.		7.22		
65.9	" Milton, Pa.		1.18		63.3	" Hinsdale, N. Y.		7.33		
93.3	" Williamsport, Pa.	1.52	2.03		70.3	" Olean, N. Y.	10.37	8.00	11.51	
117.8	" Lock Haven, Pa.	2.33	2.56		84.4	" Eldred, Pa.	10.55			
145.8	" Renovo, Pa.	3.32	3.43		96.7	" Port Allegany, Pa.	11.15		12.26	
191.0	Ar Emporium, Pa.	4.32	4.43		121.1	Ar Emporium, Pa.	12 04		f 1.11	
	Lv Emporium, Pa.	4.36	4.55			Lv Emporium, Pa.	12 13		f 1.11	
215.4	" Port Allegany, Pa.	5.17	5.40		166.3	Ar Renovo, Pa.	1.32		2.16	
227.7	" Eldred, Pa.		5.58		194.3	" Lock Haven, Pa.	2.00		3.00	
241.8	" Olean, N. Y.	6.20	6.00	6.29	218.8	" Williamsport, Pa.	2.35		3.35	
254.9	" Hinsdale, N. Y.	6.32			246.2	" Milton, Pa.	3.26			
248.8	" Ischua, N. Y.	6.40			258.7	" Sunbury, Pa.	3.47		4.39	
262.4	" Franklinville, N. Y.	6.53		6.56	312.1	Ar Harrisburg, Pa.	5.00		5.50	
267.6	" Machias, N. Y.	7.00								
273.2	" Delevan, N. Y.	7.08			312.1	Lv Harrisburg, Pa.	5.13		6.15	
276.3	" Arcade, N. Y.	7.16		† 7.14	339.2	Ar York, Pa.	6.02		6.57	
279.2	" Chaffee, N. Y.	7.26	† 6.41		395.4	" Baltimore, Md. (Penna. Sta.)	7.48		8.46	
281.8	" Protection, N. Y.	7.29			435.5	" Washington, D. C.	8.40		9.35	
285.4	" Holland, N. Y.	7.33	6.50							
290.1	" South Wales, N. Y.	7.40	f 6.55		312.1	Lv Harrisburg, Pa.	5.10		6.53	
292.5	" Blakeley, N. Y.	7.45			347.4	Ar Lancaster, Pa.	5.54		7.41	
294.9	" East Aurora, N. Y.	7.52	7.05	7.40	395.3	" Paoli, Pa.	6.53		8.40	
297.4	" Jamison Road, N. Y.	7.57				Philadelphia, Pa.				
299.2	" Elma, N. Y.	8.00			415.3	Ar Penna. Station (30th St.)	7.17		9.06	
301.6	" Spring Brook, N. Y.	8.05				" Broad St. Station	7 21		9.10	
305.4	" Ebeneser, N. Y.	8.11								
310.6	" Lord Street, N. Y.	8.22	b 7.33			Philadelphia, Pa.				
	Ar Buffalo, {Exchg. St. Sta.	8.30			415.3	Lv Broad St. Station	8.35	m10.30		
312.1	N. Y. {Central Term.	8.50	7.55	8.25		" Penna. Station (30th St.)	8.40	m10.36		
					479.1	Ar Atlantic City, N. J.	10.10	m12.00		
	Lv Buffalo, N. Y. (M. C.)		8.30							
	Ar Hamilton, Ont.(T.H.&B.)		10.35			Philadelphia, Pa.				
	" Toronto, Ont.(C.P.Ry.)		11.45		415.3	Lv Broad St. Station	7.40		9.15	
						" Penna. Station (30th St.)	8.20		9.53	
	Lv Buffalo, N. Y. (N.Y.C.)	9.15	9.15		448.6	Ar Trenton, N. J.	9.41		11.11	
	Ar Niagara Falls, N. Y.	10.21	10.21			New York, {Hudson Terminal	9.30		11.00	
	" Suspension Bridge, N. Y.	10.40	10.40		506.7	N. Y. {Penna. Station				
		AM	AM	PM			PM	PM	AM	

No. 45-571—BUFFALO DAY EXPRESS
Parlor Cars — Philadelphia to Buffalo. Washington to Buffalo—(Cafe.)
Dining Car — Philadelphia to Harrisburg.
Cafe Car — Washington to Buffalo.
Coaches — Philadelphia to Buffalo. Washington to Buffalo.

No. 570—WASHINGTON AND PHILADELPHIA EXPRESS
Parlor Cars — Buffalo to Philadelphia. Buffalo to Washington—(Cafe.) Harrisburg to Philadelphia—(Cafe.)
Cafe Cars — Buffalo to Washington.
Coaches — Harrisburg to Philadelphia. Buffalo to Philadelphia. Buffalo to Washington.

No. 574-604—DOMINION EXPRESS
Lounge Car — Buffalo to Washington—(C., D. R.
Sleeping Cars — Buffalo to Washington—(6 S.,6 Doubl Bedrooms). Buffalo to Washington—(12 S., D. R.) (2 Cars.) Buffalo to Philadelphia—(12 S., D. R.) (Sleeping cars open in Buffalo 9.0 P. M.)
Dining Car — Harrisburg to Washington.
Cafe Coach — Harrisburg to Philadelphia.
Coaches — Buffalo to Washington. Harrisburg to Philadelphia.

No. 581-575—DOMINION EXPRESS
Lounge Car — Washington to Buffalo—(C., D. R Buffet).
Sleeping Cars — Washington to Buffalo—(6 S., 6 Double Bedrooms). Washington to Buffalo—(12 S., D. R. 2 Cars.) Philadelphia to Buffalo—(12 S., D. R)
Cafe Coach — Washington to Harrisburg.
Coaches — Washington to Buffalo. Philadelphia to Harrisburg.

INFORMATION

ADJUSTMENT OF FARES—Should any misunderstanding arise with conductors or agents as to the proper fare or ticket privilege, please pay fare requested, take receipt and communicate with General Passenger Agent, Pennsylvania Station, Philadelphia 4, Pa.

CHILDREN—Under 5 years of age, free, when accompanied by parent or guardian; 5 years of age and under 12, one-half fare. 12 years of age and over, full fare.

RESPONSIBILITY—The Pennsylvania Railroad not responsible for errors in time tables, nor for inconvenience or damage resulting from delayed trains or failure to make connections, or for shortage of equipment. These schedules and equipment shown in this time table are subject to change without notice.

FORWARDING OF BAGGAGE—Passengers are urged to check baggage in advance so that it may be forwarded on a preceding train. Every effort will be made to facilitate the handling of baggage, but the Railroad cannot guarantee the forwarding of baggage on same train with owner, nor can time of arrival at destination to which checked be guaranteed.

BAGGAGE ALLOWANCE—One hundred and fifty (150) pounds of baggage not exceeding one hundred (100.00) dollars in value may be checked without additional charge for each adult passenger, and seventy-five (75) pounds not exceeding fifty (50.00) dollars in value for each child traveling on a one-half fare ticket.

Passengers have the privilege of declaring excess value on their baggage at a nominal charge of ten cents for each additional $100.00 or fraction thereof over that allowed on their tickets. Limit of valuation that may be declared on one passenger not to exceed $2,500.00.

BAGGAGE—WEIGHT, SIZE AND LIABILITY—No single piece of baggage exceeding 300 pounds in weight or 72 inches in greatest dimension, or single shipment exceeding $2,500.00 in value, will be checked. Free allowance and liability is subject to tariff stipulations as to contents, weight, value and size.

REFERENCE NOTES

† Week-days only.

§ Sunday only.

H Will not run on Memorial, Independence, Labor, Thanksgiving, Christmas and New Year's Day, or on Monday following when any of these days fall on Sunday.

b Stops only on notice to conductor to discharge passengers.

f Stops only on signal or notice to agent or conductor to receive or discharge passengers.

m On Sundays and Nov. 28, Dec. 25 and Jan. 1, leaves Broad St. Station 9.30 a. m., 30th St. Sta. 9.34 a. m., arrives Atlantic City 10.56 a. m.

y Passengers from New York change at Harrisburg.

z Passengers from New York change at Philadelphia, Pennsylvania Station (30th Street.)

F. M. WARE, General Passenger Agent
Pennsylvania Sta. (30th St.), Philadelphia 4, Pa.

ALAN B. SMITH, General Passenger Agent
Pennsylvania Station, Pittsburgh 22, Pa.

The Pennsylvania Railroad timetable effective September 29, 1946, shows a weekday morning commuter train from Olean to Buffalo stopping at Arcade at 7:16 a.m. and a Sunday-only stop for a New York City via Philadelphia and Harrisburg-to-Buffalo train stopping at Arcade at 7:14 p.m. Southbound there was a weekday afternoon commuter train from Buffalo to Olean stopping at Arcade at 6:42 p.m. There was a morning train from Buffalo making a flag stop at Arcade at 9:44 a.m., heading for Philadelphia and New York City. Arcade had been linked to Buffalo by railroad passenger train service since 1871. At its peak the Pennsylvania Railroad had about 750 regular commuters on its Buffalo-to-Olean commuter service. After the 1920s, ridership declined as more motor vehicles entered the highways. The final commuter train known as the "Jerk" was train No. 991 from Olean to Buffalo and train No. 990 from Buffalo to Olean. That train was discontinued on January 24, 1948. The withdrawal of that train meant a change of travel habit for all its riders.

PENNSYLVANIA RAILROAD

Effective October 25, 1964

NEW YORK–PHILADELPHIA–WASHINGTON to WILLIAMSPORT–ERIE–BUFFALO

Miles	EASTERN STANDARD TIME	Buffalo Day Express 25-573 Sun. only	Buffalo Day Express 25-571 Except Sun.	Northern Express 3-575 Daily
		AM	AM	PM
....	Lv New York, N. Y. { Penna. Station	7.30	7.30	v 6.50
....	{ Hudson Terminal	7.07	7.07	v 6.37
....	" Newark, N. J.	7.44	7.44	v 7.04
....	" Trenton, N. J.	8.30	8.30
....	" North Philadelphia, Pa.	9.01	9.01	c 8.17
....	" Paoli, Pa.	9.37	9.37	8.60
....	" Lancaster, Pa.	10.22	10.22	9.43
....	Ar Harrisburg, Pa.	11.10	11.10	10 20
....	Lv Washington, D. C.	▲ 7.00	▲ 7.00	6.45
....	" Baltimore, Md. (Penna. Sta.)	8.15	8.15	7.40
....	" York, Pa.	9.56	9.56	9.18
....	Ar Harrisburg, Pa.	10.45	10.45	10.11
.0	Lv Harrisburg, Pa.	11.25	11.25	11.35
27.0	" Millersburg, Pa.	12.01		f12.10
53.4	" Sunbury, Pa.	12.34	12.31	12.41
62.1	" Montandon, Pa.			f 1.00
65.9	" Milton, Pa. (q Lewisburg)	12.51	1.00	f 1.07
70.4	" Watsontown, Pa.			f 1.13
77.0	" Montgomery, Pa.			f 1.21
80.9	" Muncy, Pa.	1.11	1.20	
93.3	Ar Williamsport, Pa.	1.55	2.05	2.20
93.3	Lv Williamsport, Pa.	1.55	2.05	2.20
104.9	" Jersey Shore, Pa.	f 2.27		
117.8	" Lock Haven, Pa.	2.45	2.57	3.17
145.8	" Renovo, Pa.	3.17	3.37	3.58
191.0	Ar Emporium, Pa.	4.35	4.55	5.17
	Train No. --->			581
191.0	Lv Emporium, Pa.			5.35
118.7	" St. Marys, Pa.			6.16
125.1	" Ridgway, Pa.			6.46
130.8	" Johnsonburg, Pa.			7.02
146.5	" Kane, Pa.			7.30
161.9	" Sheffield, Pa.			b 7.56
175.3	" Warren, Pa.			8.20
185.7	" Youngsville, Pa.			b 8.32
205.9	" Corry, Pa.			9.10
214.9	" Union City, Pa.			9.27
240.3	Ar Erie, Pa.			10.05
191.0	Lv Emporium, Pa.	4.35	4.55	5.17
116.4	" Port Allegany, Pa.	5.14	5.34	6.20
187.7	" Eldred, Pa.	5.30	5.54	
141.8	" Olean, N. Y.	5.50	6.12	6.53
168.4	" Franklinville, N. Y.	f 6.16	6.57	
176.5	" Arcade, N. Y.		f 7.16	
194.9	" East Aurora, N. Y.	6.55	7.40	8.05
113.1	Ar Buffalo, N. Y. (Central Term.)	7.35	8.15	8.40
		PM	PM	AM

WASHINGTON NEW YORK PHILADELPHIA WILLIAMSPORT BUFFALO

Read Down Read Up

Effective October 29, 1967

Northern Express 575 Daily	Miles	Local Time	Southern Express 574 Daily
PM			AM
7.00		Lv Washington, D. C. Ar	9.10
7.55		" Baltimore, Md. (Penna. Sta.) "	8.10
9.33		" York, Pa. "
10 25		Ar Harrisburg, Pa. Lv	5.40
3		<--- Connecting Train No. --->	4
v 6 45		Lv .. New York, N. Y. Penna. Station .. Lv	8.15
v 7 00		" Newark, N. J. "	d 7.52
		" Trenton, N. J. "	d 7.05
c 8.14		" North Philadelphia, Pa. "	d 6.25
8 46		" Paoli, Pa. "	d 5.56
9 38		" Lancaster, Pa. "
10 15		Ar Harrisburg, Pa. Lv	4.29
11 35	.0	Lv Harrisburg, Pa. Ar	4.20
f12 13	27.0	" Millersburg, Pa. "
12.48	53.4	" Sunbury, Pa. "	2.50
f 1.10	62.1	" Montandon, Pa. "	f 2.37
f 1.17	65.9	" Milton, Pa. (q Lewisburg) "
f 1.24	70.4	" Watsontown, Pa. "	f 2.27
f 1.33	77.0	" Montgomery, Pa. "	
	80.9	" Muncy, Pa. "	
2.20	93.3	Ar Williamsport, Pa. Lv	1.20
2.20	93.3	Lv Williamsport, Pa. Ar	1.20
	104.9	" Jersey Shore, Pa. "	
3.15	117.8	" Lock Haven, Pa. "	12.36
4.01	145.8	" Renovo, Pa. "	11.52
5.04	191.0	" Emporium, Pa. "	10.52
5.44	213.4	" Port Allegany, Pa. "	10.12
	227.7	" Eldred, Pa. "	
6 18	241.8	" Olean, N. Y. "	9 30
	262.4	" Franklinville, N. Y. "	
	276.3	" Arcade, N. Y. "	
7 37	295.9	" East Aurora, N. Y. "	8.21
8 15	312.1	Ar .. Buffalo, N. Y. (Central Term.) Lv	7.45
AM			PM

REFERENCE NOTES

c Stops only to receive passengers.
d Stops only to discharge passengers.
f Stops only on signal or notice to agent or conductor to receive or discharge passengers.
q Beachel Cab Co. operates taxi service between Lewisburg and Milton— Phone 742-9651. Fare one way $1.60 for one passenger and 50¢ for each additional passenger.
v Stops only to receive passengers for points west of Philadelphia.

Pennsylvania Railroad

The October 25, 1964, Pennsylvania Railroad timetable shows no southbound train from Buffalo to Philadelphia stopping at Arcade; however, the northbound train *Buffalo Day Express* had a flag stop at Arcade at 7:16 p.m. An overlay of the October 29, 1967, Pennsylvania Railroad schedule shown on the right shows only one train each way from Buffalo via Philadelphia to New York City, and that train did not stop at Arcade. The Penn Central Transportation Company timetable for September 16, 1968, no longer shows Buffalo-to-Philadelphia train service. The Pennsylvania Railroad had many lines in western New York. The Buffalo line extended from Buffalo south to Emporium, Pennsylvania. It began as the Buffalo and Allegheny Valley Railroad Company chartered on May 30, 1853. Through a series of mergers it became the Western New York and Pennsylvania Railroad in September 1887 and was acquired by the Pennsylvania Railroad on July 31, 1900.

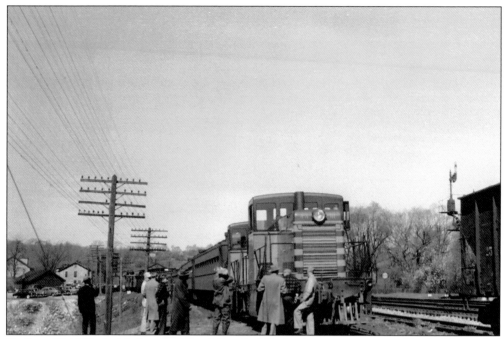

On June 25, 1952, the National Railway Historical Society's excursion powered by double-headed diesels No. 110, built in June 1941, and No. 111, built in April 1947, pulling six rented Erie Railroad Stillwell coaches (designed by L. B. Stillwell) plus Arcade and Attica Railroad cabooses No. 303 and No. 304 are ready to head southward on the west leg of the wye at Attica station. (Patrick D. Connors collection.)

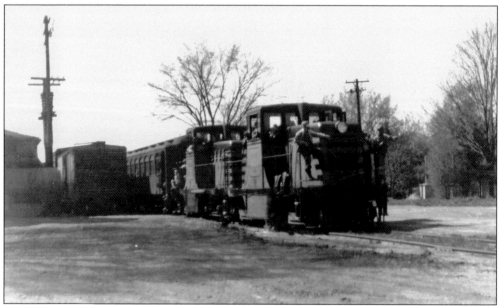

Arcade and Attica Railroad diesels No. 111 and No. 110 are powering the National Railway Historical Society's excursion at Attica on June 25, 1952. Each of these locomotives weighed 44 tons, was rated 380 horsepower, and was built by the General Electric Company plant in Erie, Pennsylvania. (Patrick D. Connors collection.)

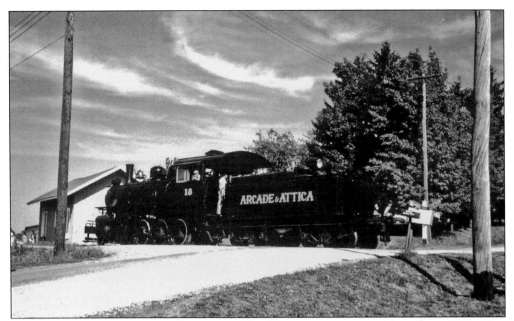

Having passed the Arcade and Attica Railroad station at Curriers, locomotive No. 18 is backing around the train to get at the other end of the train for the trip back to Arcade on September 8, 1962. The American Locomotive Company built this locomotive in November 1920 at its Cooke Locomotive and Machine Works Paterson, New Jersey, facility. (Photograph by Kenneth C. Springirth.)

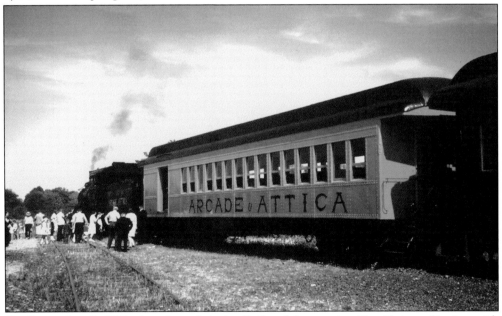

On September 8, 1962, Arcade and Attica Railroad locomotive No. 18 is at Curriers with passengers permitted to go through the cab of the steam locomotive. The locomotive, a Consolidation type with a 2-8-0 wheel arrangement having a single leading truck and four powered driving axles, was acquired in March 1962 from the Boyne City Railroad for excursion service. (Photograph by Kenneth C. Springirth.)

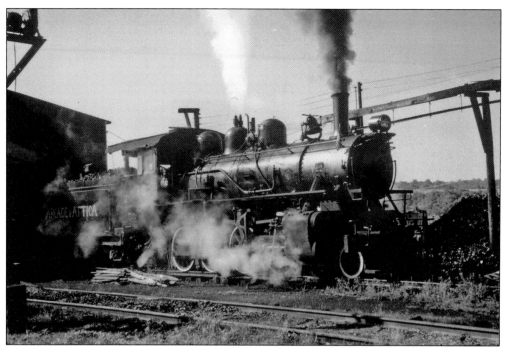

Getting ready for the next trip, Arcade and Attica Railroad steam locomotive No. 18 is at the Arcade engine house on July 24, 1963. The locomotive was built to serve Cuban Sugar Service but previously served the Charcoal Iron Company, the Newberry Iron Company, and the Boyne City Railroad. (Photograph by Kenneth C. Springirth.)

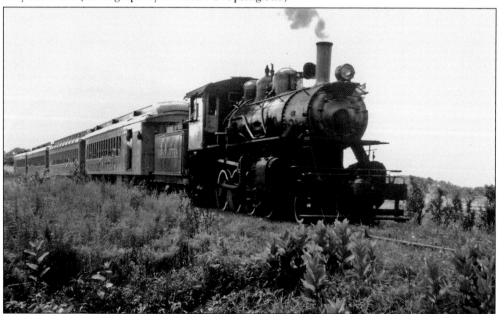

An Arcade and Attica Railroad passenger train powered by locomotive No. 18 is hauling four previous Delaware, Lackawanna and Western Railroad coaches north to Curriers on July 24, 1963. The railroad had instituted steam locomotive passenger service to supplement revenues, and the response in those early years was excellent. (Photograph by Kenneth C. Springirth.)

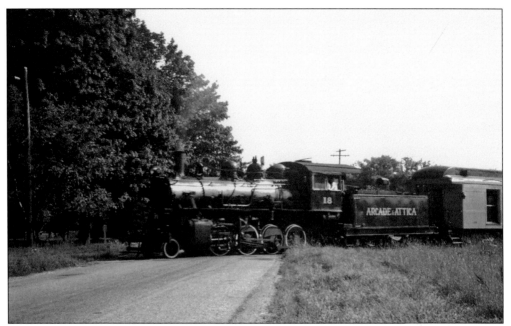

Curriers Road is the scene for Arcade and Attica Railroad locomotive No. 18 heading northbound on July 24, 1963. This locomotive had been purchased by the Boyne City Railroad on September 16, 1946, and was taken out of service on August 1, 1950. The Boyne City Railroad was abandoned during 1982. (Photograph by Kenneth C. Springirth.)

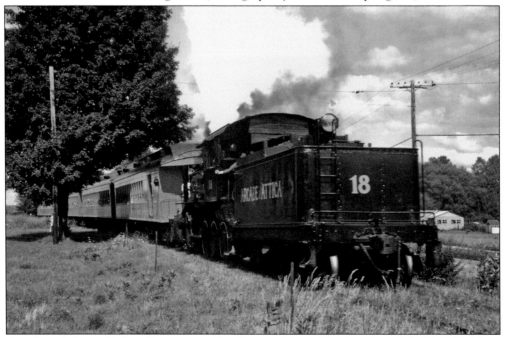

Arcade and Attica Railroad locomotive No. 18 is southbound for Arcade on July 24, 1963. There was no turnaround facility for the locomotive at Curriers. Hence the locomotive headed backward for the southbound run to Arcade. The railroad's rural character attracted riders from the nearby metropolitan areas of Buffalo and Rochester. (Photograph by Kenneth C. Springirth.)

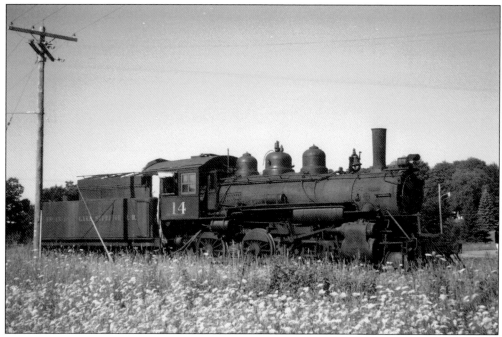

Former Escanaba and Lake Superior Railroad locomotive No. 14 is at Arcade in this July 24, 1963, scene. Built by Baldwin Locomotive Works in 1917, this locomotive had just been purchased by the Arcade and Attica Railroad for $5,000 and was later refurbished for its thriving steam locomotive passenger excursion service. (Photograph by Kenneth C. Springirth.)

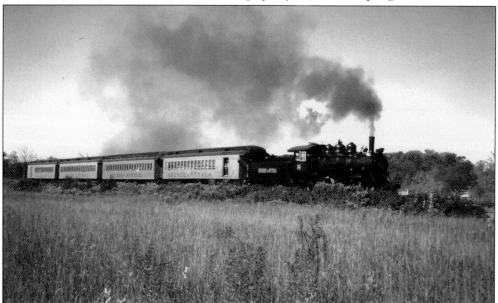

Four previous Delaware, Lackawanna and Western Railroad passenger cars are being pulled by Arcade and Attica Railroad locomotive No. 14 northbound near Curriers Road heading for the hamlet of Curriers on September 7, 1964. Most of the land along the railroad was in pasture, making it a delightful excursion for city dwellers just 40 miles away in Buffalo. (Photograph by Kenneth C. Springirth.)

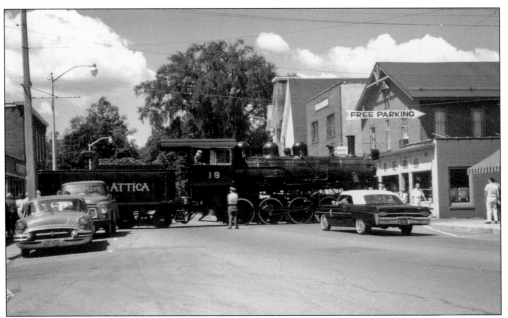

Main Street in downtown Arcade finds Arcade and Attica Railroad locomotive No. 18 northbound for Curriers on July 24, 1963. The railroad has contributed to the vitality of the business community. While Letchworth State Park was the number one attraction, this railroad became the second major tourist attraction in Wyoming County. (Photograph by Kenneth C. Springirth.)

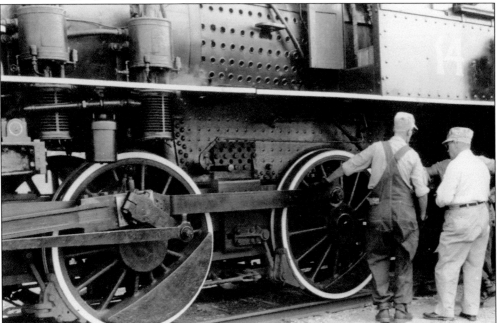

Arcade and Attica Railroad engine No. 14 receives its normal inspection during excursion service by Emmett "Bud" King, the tall engineer on the left discussing maintenance needs, around 1964. Steam locomotives required careful attention that the railroad was able to provide by its skilled employees. (Arcade and Attica Railroad collection.)

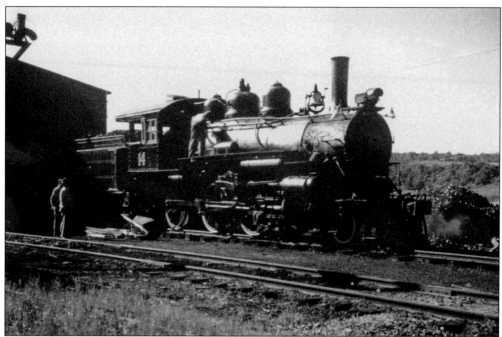

Ten wheeler–type locomotive No. 14 with a 4-6-0 wheel arrangement is at the Arcade and Attica Railroad engine house on September 7, 1964, preparing for the next passenger run. The railroad crews meticulously cared for this locomotive. The labor force in this region was noted for its high work ethic. (Photograph by Kenneth C. Springirth.)

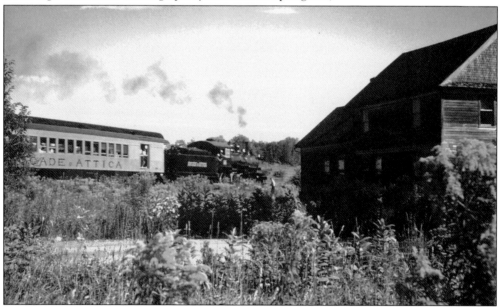

Northbound Arcade and Attica Railroad locomotive No. 14 is piloting a passenger run to Curriers on September 7, 1964. While Arcade has a number of industries, the area north to Curriers served by the railroad retained its rural charm with many vintage farm structures. Passenger service operated from Arcade to Curriers while freight service continued north to the Reisdorf Brothers Feed Mill at North Java. (Photograph by Kenneth C. Springirth.)

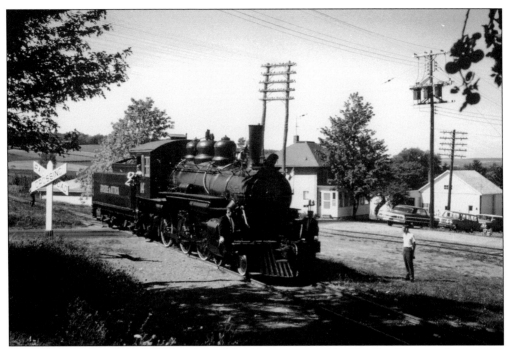

Arcade and Attica Railroad locomotive No. 14 is crossing Chaffee Road to couple onto the passenger cars at Curriers on September 7, 1964, for the trip back to Arcade. On the engine at the left is Cecil A. Lester, brakeman, and on the right of the engine is Howard Hopkins, conductor. (Photograph by Kenneth C. Springirth.)

The 1963 Arcade and Attica Railroad brochure advertises the historical, educational, and photographic features of the Arcade-to-Curriers 15-mile round-trip. This was excellent farming country, which the railroad proudly noted, "Dairy products shipped the world over from finest grazing herds—which sometimes stop the trains!" (Arcade and Attica Railroad collection.)

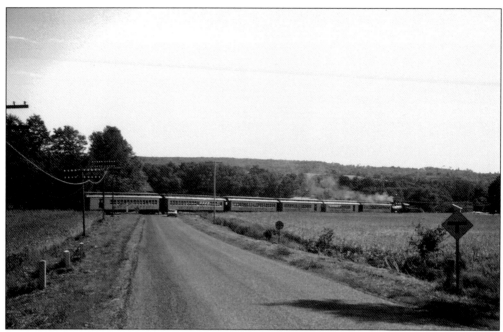

A southbound Arcade and Attica Railroad train powered by locomotive No. 14, with its 58-inch-diameter driver wheels, is passing Curriers Road near Arcade on September 7, 1964. Over the years this line has provided an important rail link for southwestern Wyoming County. (Photograph by Kenneth C. Springirth.)

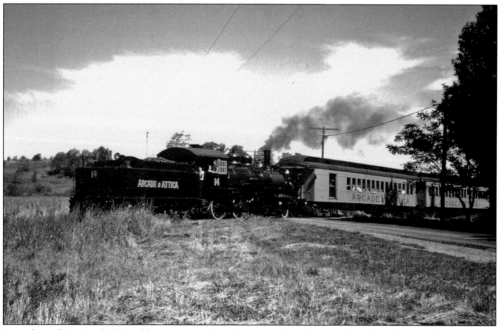

Arcade and Attica Railroad locomotive No. 14 is crossing Curriers Road for the southbound trip back to the Arcade depot on September 7, 1964. This locomotive originally served the Escanaba and Lake Superior Railroad operating in northeastern Wisconsin and the Upper Peninsula of Michigan. (Photograph by Kenneth C. Springirth.)

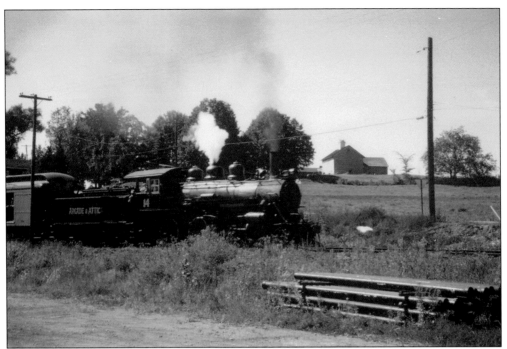

Northbound out of Arcade, locomotive No. 14 is heading for Curriers on September 7, 1964. Students of rail transportation and the general public have found this a pleasant place to ride and enjoy trains. (Photograph by Kenneth C. Springirth.)

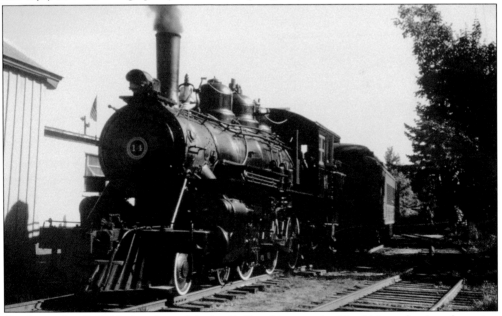

On September 7, 1964, Arcade and Attica Railroad locomotive No. 14 is at the Arcade station ready for the next trip. Historically railroads have played an enormous role in the growth of the nation, serving as the commercial rivers. Over the years many of the tributaries have been abandoned, but this line has survived by hard work and the ability to get state funding for track improvements. (Photograph by Kenneth C. Springirth.)

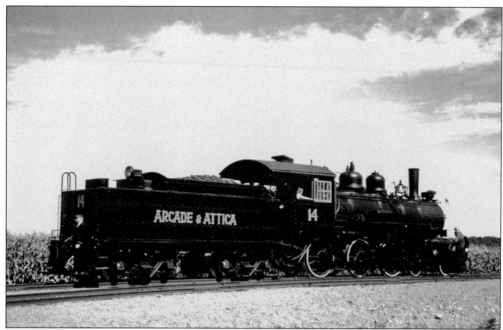

On the siding next to a cornfield at Curriers, Arcade and Attica Railroad locomotive No. 14 is backing around the train for the return trip to Arcade on September 7, 1964. Howard Hopkins, conductor, is on the tender to make sure the trackage is clear for the locomotive. (Photograph by Kenneth C. Springirth.)

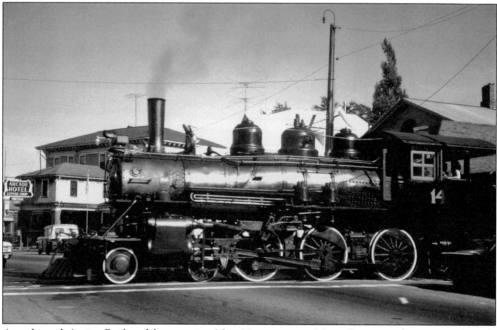

Arcade and Attica Railroad locomotive No. 14 is crossing Main Street in downtown Arcade on September 7, 1964. Attracting a large number of riders benefited Arcade businesses. With its neat stores and variety of private homes, Main Street makes a great place to shop and take a stroll. (Photograph by Kenneth C. Springirth.)

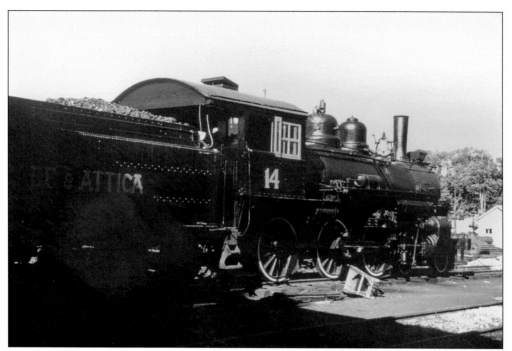

Arcade and Attica Railroad locomotive No. 14 is at Arcade near the engine house on September 7, 1964. The railroad has made Arcade a destination point for thousands of riders where visitors can enjoy an excellent village park, a fine public library, and an attractive commercial district. (Photograph by Kenneth C. Springirth.)

Amid a picturesque Wyoming County dairy farm, Arcade and Attica Railroad locomotive No. 14 is southbound for Arcade on September 7, 1964. Farming has played a key role in the railroad's existence. (Photograph by Kenneth C. Springirth.)

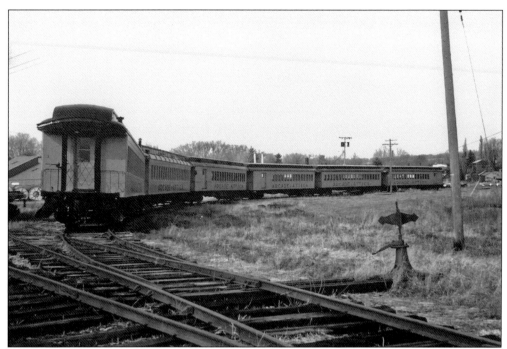

Six Arcade and Attica Railroad passenger cars are on the siding near the engine house at Arcade on November 2, 1965. Car sides were a bright orange with a black roof and lettering. These cars were built by the Pullman Company for the Delaware, Lackawanna and Western Railroad. (Photograph by Kenneth C. Springirth.)

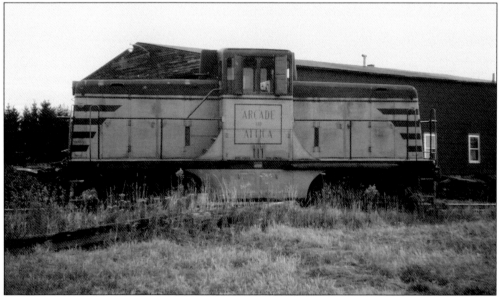

On November 2, 1965, Arcade and Attica Railroad diesel locomotive No. 111, General Electric Company serial No. 28346, is at Arcade by the engine house. This was the second new diesel electric locomotive purchased by the railroad. In a diesel electric locomotive, the diesel engines supply mechanical power, which the generators convert to electric power for driving the traction motors geared to the axles. (Photograph by Kenneth C. Springirth.)

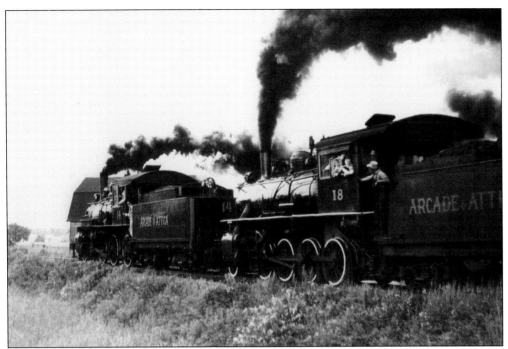

On June 25, 1967, steam locomotives No. 14 and No. 18 are double-heading a 50th anniversary special, which marked the beginning of the Arcade and Attica Railroad in 1917. The train was heading north from Genesee Road. Students of transportation were allowed in the locomotive cabs by a very accommodating railroad. (Photograph by Ken Kraemer.)

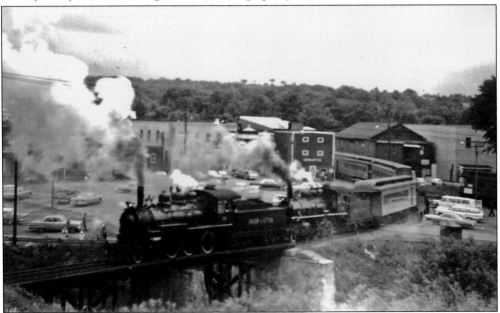

The double-headed 50th anniversary special of the Arcade and Attica Railroad with locomotives No. 14 and No. 18 is northbound passing the municipal parking lot behind the downtown Arcade business district, as seen from the hill near North Street on June 25, 1967. (Patrick D. Connors collection.)

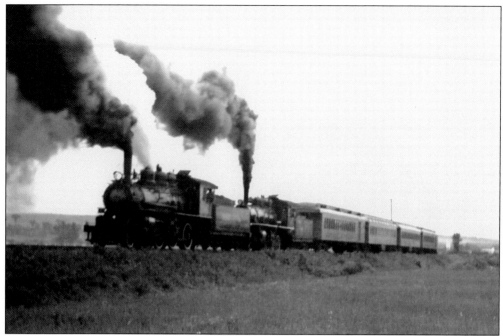

On June 25, 1967, the double-headed 50th anniversary special of the Arcade and Attica Railroad is northbound ready to cross Genesee Road. This was an accomplishment for the railroad that seven years earlier the July 10, 1960, *Courier-Express* newspaper of Buffalo noted had scant hope for survival because of high costs and truck competition. (Patrick D. Connors collection.)

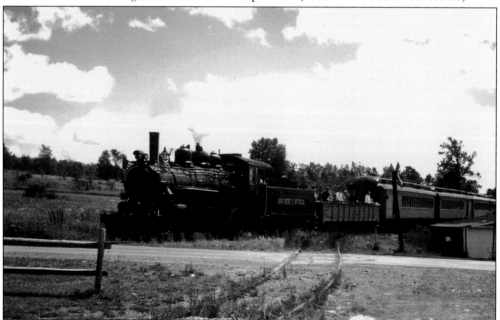

Arcade and Attica Railroad locomotive No. 14 is ready to cross Chaffee Road to stop at the station at Curriers the northern terminus of this excursion on July 17, 1976. The curved track noted in the picture is the passing siding for the locomotive to back around the train for the return trip to Arcade. (Photograph by Kenneth C. Springirth.)

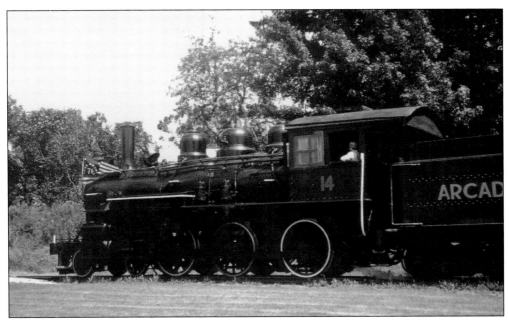

On July 17, 1976, Arcade and Attica Railroad locomotive No. 14 is commemorating the United States bicentennial with the flag in front of the locomotive. The railroad and the communities it serves over the years have proudly displayed the nation's flag. (Photograph by Kenneth C. Springirth.)

A "fireless cooker" type locomotive with a 0-4-0 wheel arrangement is at the Arcade and Attica Railroad at Arcade on July 17, 1976. This engine was built by H. K. Porter Company in August 1930 and was obtained by the railroad for display purposes during 1971. It was later sent to the Erie County Fairgrounds at Hamburg, New York. (Photograph by Kenneth C. Springirth.)

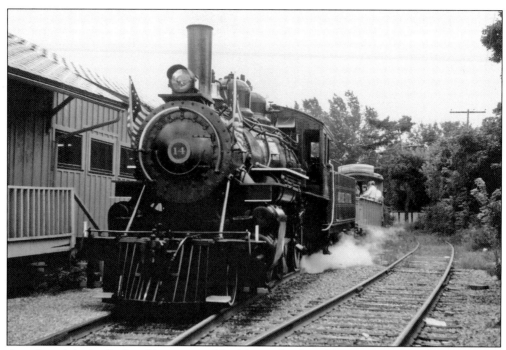

Arcade and Attica Railroad locomotive No. 14 is at the Arcade station awaiting departure time on July 17, 1976. Arcade is an excellent vacation spot that is only 25 miles from Letchworth Park, the "Grand Canyon of the East." (Photograph by Kenneth C. Springirth.)

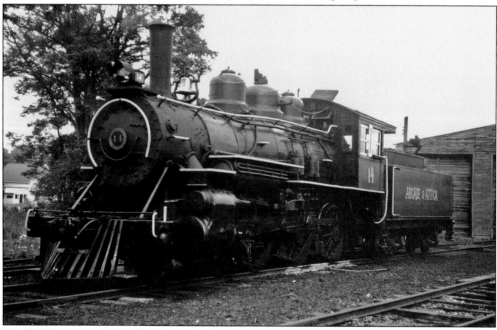

With yellow painted hand rails and side windows plus orange lettering, Arcade and Attica Railroad locomotive No. 14 is parked in front of the Arcade engine house on July 15, 1972. The three-stall engine house is on the east side of the wye where the trackage to Arcade Junction swings to the west. (Photograph by Kenneth C. Springirth.)

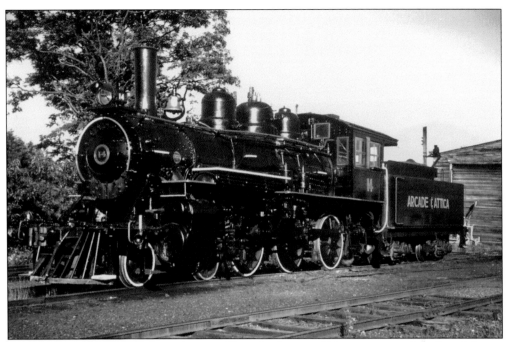

Beautifully painted in black complemented by red, white, and blue trimming, Arcade and Attica Railroad locomotive No. 14 is at the Arcade engine house on July 17, 1976. The engine house is located south of the Arcade train station. (Kenneth C. Springirth.)

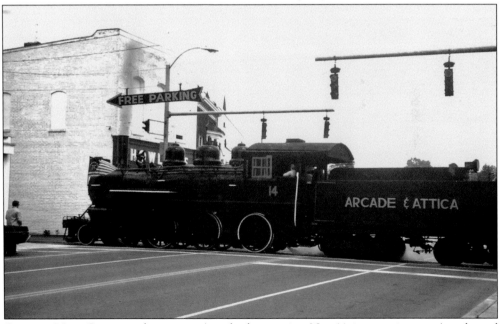

Crossing Main Street in downtown Arcade, locomotive No. 14 is powering an Arcade and Attica Railroad passenger train northward to Curriers on July 17, 1976. Visitors traveling through Main Street are often quite surprised to see a steam locomotive, which is the only full-size operating steam locomotive in regular excursion service in New York State. (Photograph by Kenneth C. Springirth.)

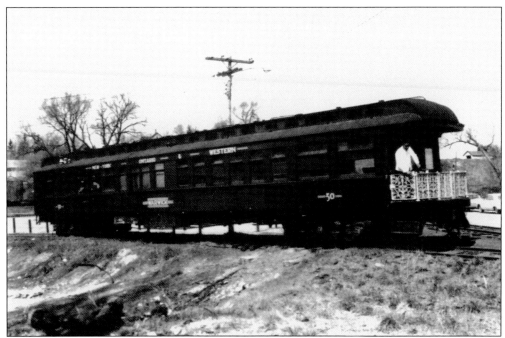

New York, Ontario and Western Railroad business car No. 30, *Warwick*, is at Arcade on the siding near the municipal parking lot north of Main Street. Jackson and Sharpe Company of Wilmington, Delaware, built this steel underframe car weighing 135,200 pounds in 1886. Seating 22, the car was used to transport railroad officials. (Arcade and Attica Railroad collection.)

The plush interior of the New York, Ontario and Western Railroad car No. 30 shows the formal dining area. Woodwork was solid hand-carved oak in the front area and observation lounge. Bedrooms were cherry, and the dining room was mahogany. This car was open for tours on weekends when the excursion train was in service. (Photograph by Lucy Monthie.)

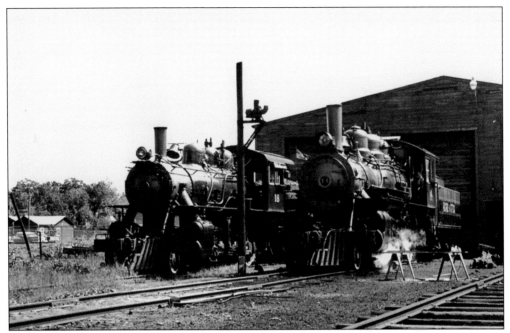

Locomotives No. 18 and No. 14 are in front of the Arcade shop. Both engines were alternately used on the Arcade and Attica Railroad from 1964 to 1981. When the railroad completely dieselized in 1947, it reduced operating expenses. However, truck transportation had cut revenues severely, and the excursion service provided a new source of revenue. (Patrick D. Connors collection.)

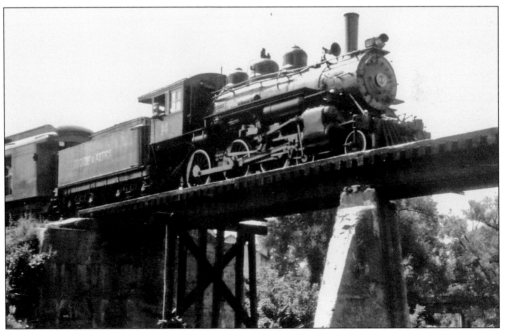

Northbound locomotive No. 14 is crossing the bridge over Cattaraugus Creek. This was the former bridge with the central pier. It was replaced with the current structure in 1980, which no longer has the central pier, thus improving water flow in the creek. (Cecil A. Lester collection.)

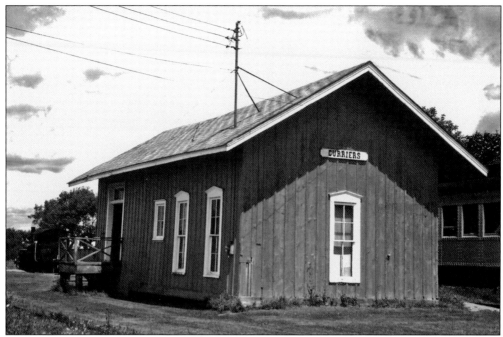

The picturesque depot at the hamlet of Curriers is the terminus for Arcade and Attica Railroad passenger service as locomotive No. 14 has just pulled in on July 17, 1976. This depot was an example of stations that once existed in small communities across the United States. (Photograph by Kenneth C. Springirth.)

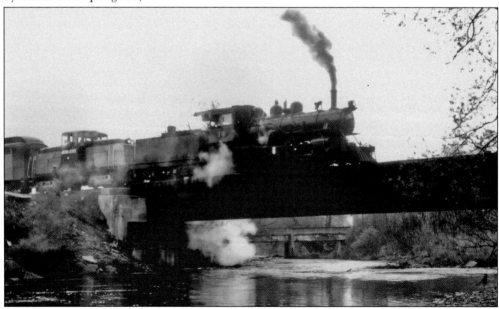

Steam locomotive No. 18 and diesel No. 111 are pulling a northbound train crossing Cattaraugus Creek in the village of Arcade on May 16, 1981, on a centennial excursion marking the 100th anniversary of the first Tonawanda Valley Railroad passenger train into Arcade. This train was sponsored by the Arcade and Attica Railroad and the Western New York Railway Historical Society. (Arcade and Attica Railroad collection.)

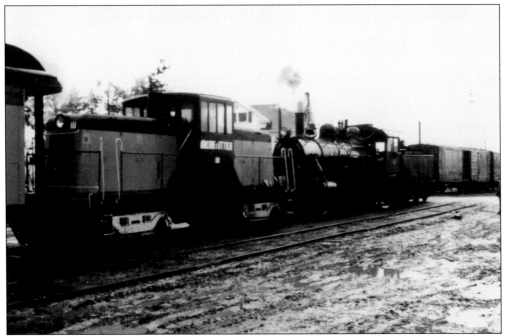

On May 16, 1981, Arcade and Attica Railroad diesel No. 111 and steam locomotive No. 18 are near the Reisdorf Brothers Feed Mill at North Java ready to head south to Arcade. This special centennial excursion operated over the entire line, including the freight-only track from Curriers to North Java. (Arcade and Attica Railroad collection.)

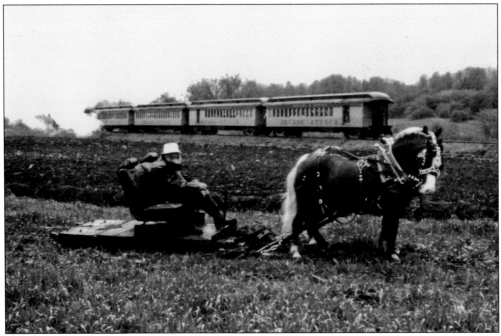

The southbound Arcade and Attica Railroad centennial excursion using diesel No. 111 and steam locomotive No. 18 has just crossed Genesee Road passing a farmer and horse team working a field on the trip back to Arcade on May 16, 1981. (Photograph by Devan Lawton.)

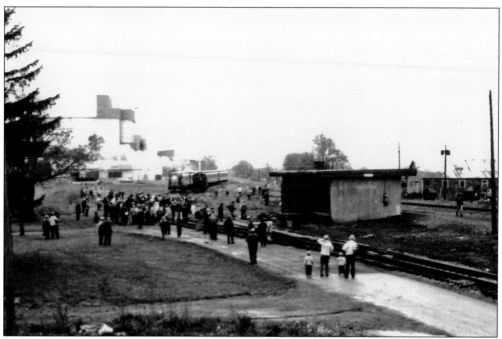

Rail enthusiasts and spectators are in abundance at Arcade Junction to view the special Arcade and Attica Railroad train with steam locomotive No. 18 and diesel locomotive No. 111 on May 16, 1981. The shelter just to the right of the center of the picture is the former Pennsylvania Railroad passenger station at Arcade. (Photograph by Jeffrey C. Mason; Arcade town historian collection.)

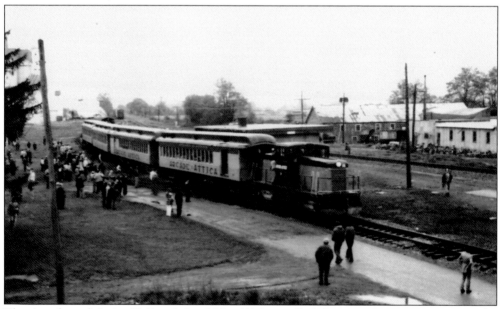

The Arcade and Attica Railroad diesel No. 111 has pulled the special passenger train to the former Pennsylvania Railroad station at Arcade on May 16, 1981. This section of track between Arcade Junction and Arcade was normally used by freight trains making this excursion a special event. (Photograph by Jeffrey C. Mason; Arcade town historian collection.)

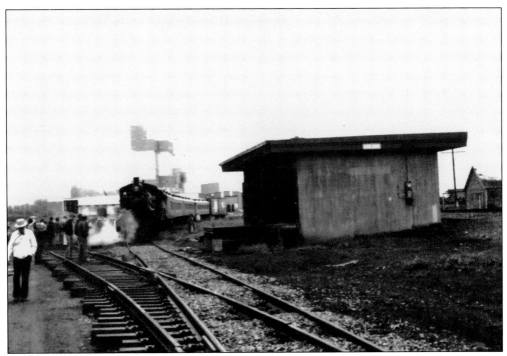

The former Pennsylvania Railroad passenger station at Arcade is the setting for a special excursion with steam engine No. 18 in view on the Arcade and Attica Railroad on May 16, 1981. This station constructed during 1941 replaced the original station that was built in 1872. (Photograph by Jeffrey C. Mason; Arcade town historian collection.)

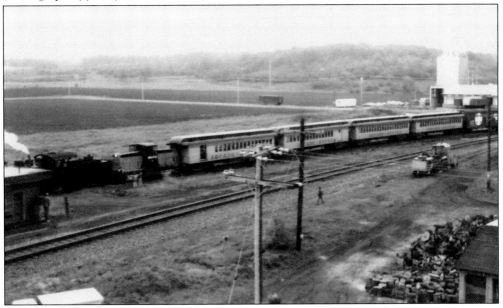

On May 16, 1981 an Arcade and Attica Railroad special train using steam locomotive No. 18 and diesel No. 111 is at the Arcade interchange with Consolidated Rail Corporation, which before the Penn Central Transportation Company was the Pennsylvania Railroad line from Buffalo to Harrisburg. (Photograph by Jeffrey C. Mason; Arcade town historian collection.)

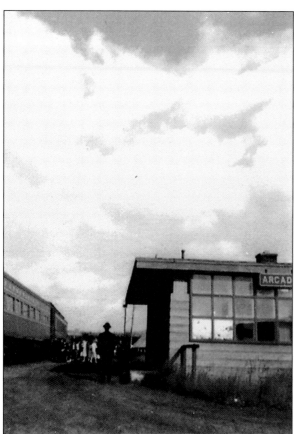

A Pennsylvania Railroad passenger train is at the Arcade passenger shelter. The *Official Guide of the Railway* for June 1916 showed five southbound and five northbound passenger trains stopping at Arcade Monday through Saturday. (Friends of the Arcade and Attica Railroad, Inc., collection.)

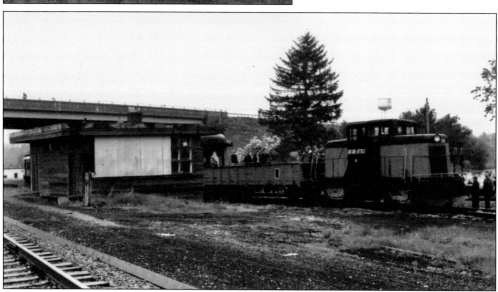

Arcade and Attica Railroad diesel No. 111 with an excursion train is at the Arcade passenger shelter of the Pennsylvania Railroad in 1982. At one time, there were occasions when the Pennsylvania Railroad regular scheduled passenger train would stop at Arcade on request to connect with an excursion train. (Arcade and Attica Railroad collection.)

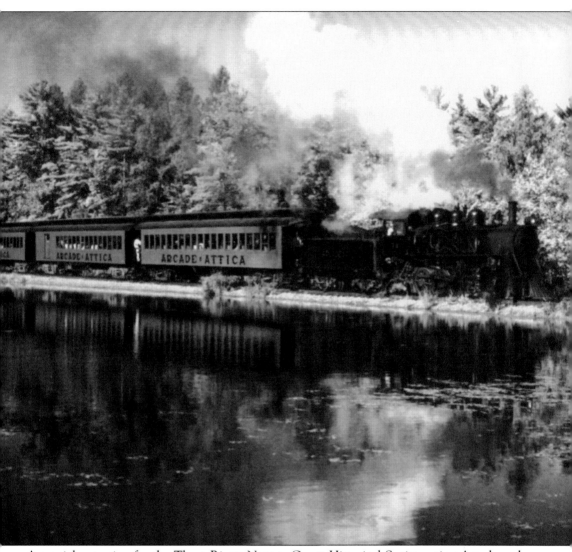

A special excursion for the Three Rivers Narrow Gauge Historical Society using Arcade and Attica Railroad steam locomotive No. 18 is passing the picturesque reflecting pool near the Welch Road crossing on July 27, 1991, on a northbound run to North Java. This was its annual convention held in Arcade that year in conjunction with the 150th anniversary celebration of Wyoming County. The train operated on trackage between Curriers and North Java that was not normally used in regular passenger excursion service. The railroad was originally built by the Tonawanda Valley Railroad as a three-foot narrow-gauge railroad. Narrow-gauge railroads had lower construction costs and proportionally smaller rolling stock. Derailments, severe winter storms, and financial problems resulted eventual ownership by the Buffalo, Attica and Arcade Railroad. Spencer S. Bullis was elected president of the company, and the line was converted to standard gauge with service from Attica to Arcade resuming on December 1, 1895. (Photograph by Duncan Richards.)

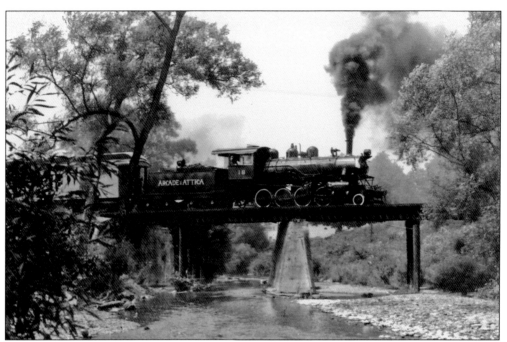

Steam locomotive No. 18 is heading north to Curriers crossing Cattaraugus Creek over the former bridge that had the central pier. In 1980, this bridge was replaced, and the central pier was eliminated. (Arcade and Attica Railroad collection.)

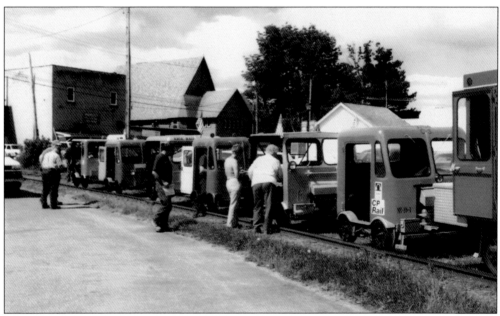

A group of railroad speeder cars are on the Arcade and Attica Railroad trackage at the municipal parking lot in Arcade in 2002. A speeder is a motorized vehicle used by track inspectors and work crews to reach work sites via the railroad track. By the 1990s, speeders were replaced by motor vehicles having flanged wheels that can be lowered for rail operation. (Photograph by Chris Lester.)

The former New York, Ontario and Western Railroad car *Warwick*, passing by the Arcade train station, is leaving the Arcade and Attica Railroad on October 3, 2002. Pres. Grover Cleveland reportedly used this car on his honeymoon. (Photograph by Hugh P. Ely; Arcade town historian collection.)

On Main Street just east of the Arcade and Attica Railroad passenger station, the former New York, Ontario and Western Railroad car the *Warwick* is on a low bed trailer turning onto the proper highway lane on October 3, 2002. The car had been referred to as the "Grover Cleveland Honeymoon Car." (Photograph by Hugh P. Ely, Arcade town historian collection.)

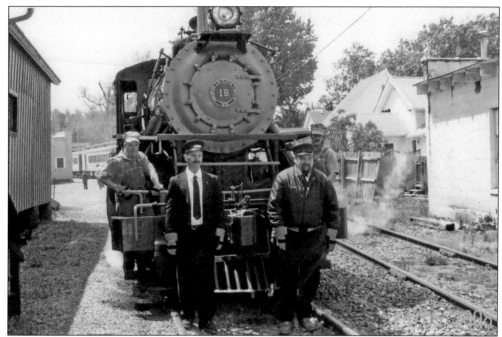

After an extensive rehabilitative program to meet new federal regulations, Arcade and Attica Railroad locomotive No. 18 is back in service on May 24, 2008, with the crew, from left to right, Brad Mapes, Patrick D. Connors, Sam Kish, and Jim Schueler. The locomotive was out of service from the fall of 2001 to April 2008. (Photograph by Chris Lester.)

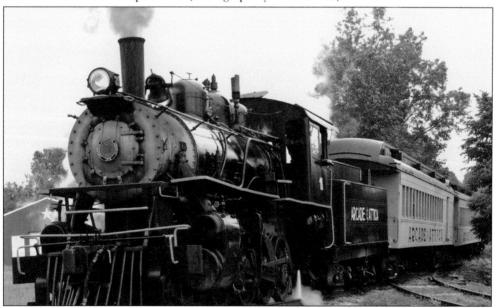

A special train for the media is arriving at Curriers on June 18, 2008. It was important for the news media to know that steam locomotive No. 18 was back in service. This short-line railroad serves as a tributary to the Buffalo and Pittsburgh Railroad. The Arcade and Attica Railroad survived while many railroad companies have disappeared in the United States. (Photograph by Patrick D. Connors.)

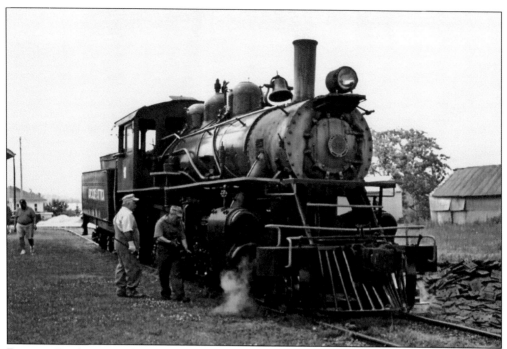

Engineer Brad Mapes is lubricating steam locomotive No. 18 at Curriers before the return trip to Arcade on July 19, 2008. Fireman Chris Lester is ready with wrench in hand to handle his part of servicing the locomotive. (Photograph by Kenneth C. Springirth.)

On July 23, 2008, Arcade and Attica Railroad diesel locomotive No. 112, in its orange and black paint scheme, is southbound ready to cross Genesee Road for the return trip to Arcade. This 400-horsepower locomotive weighed 65 tons. (Photograph by Kenneth C. Springirth.)

With track work in progress, Arcade and Attica Railroad diesel No. 112 is used in place of the steam locomotive on July 23, 2008, as conductor Sam Kish prepares to flag the Main Street crossing in Arcade. General Electric Company built this 65-ton locomotive in May 1945. This locomotive handles freight train assignments during the week. (Photograph by Kenneth C. Springirth.)

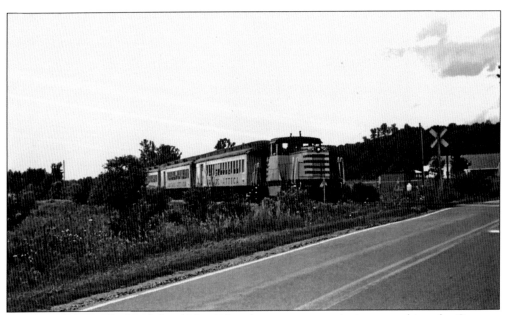

Arcade and Attica Railroad diesel No. 112 with a passenger train is approaching the Genesee Road crossing in this rural setting on July 23, 2008. This locomotive was purchased from the City of Colorado Springs Municipal Power for $28,000 and was delivered to Arcade via railroad flatcar on February 19, 1988. (Photograph by Kenneth C. Springirth.)

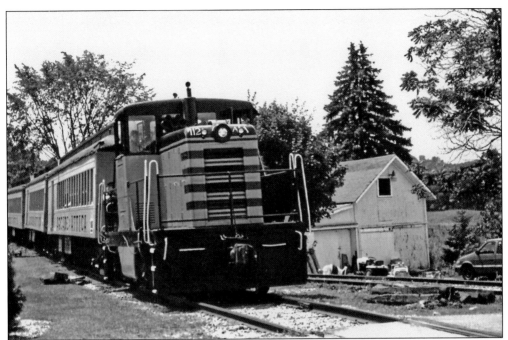

The picturesque hamlet of Curriers finds Arcade and Attica Railroad locomotive No. 112 arriving with the passenger train on July 23, 2008. This was a well-worth-it trip to ride, photograph, and experience the atmosphere of a scenic railroad. Its existence was a tribute to employees, management, railroad passengers, and the community. (Photograph by Kenneth C. Springirth.)

At Curriers, locomotive No. 112 uses the passing siding to move to the other end of the train for the trip back to Arcade on July 23, 2008, as conductor Sam Kish watches to make sure the track was clear for safe passage of the locomotive. This provided an opportunity for passengers to view the locomotive and tour the historic station. (Photograph by Kenneth C. Springirth.)

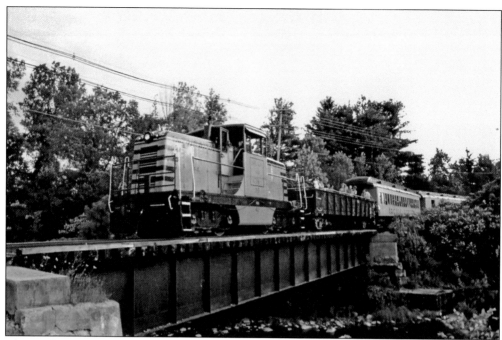

The southbound Arcade and Attica Railroad train with locomotive No. 112, in a sharp orange and black paint scheme, is crossing the bridge over Cattaraugus Creek within a short distance from the Arcade depot on July 23, 2008. This was one of the scenic highlights of the trip that traversed a region of fields, farms, pasture, and woodlands. (Photograph by Kenneth C. Springirth.)

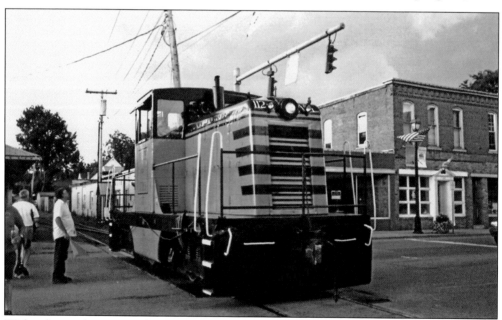

With a heavy downpour of rain minutes away, Arcade and Attica Railroad general manager George Ling serves as flagman to provide safe passage for locomotive No. 112 and pedestrians crossing Main Street in Arcade on July 23, 2008. Since 1962, the railroad has played a key role in attracting tourists to this part of Wyoming County. (Photograph by Kenneth C. Springirth.)

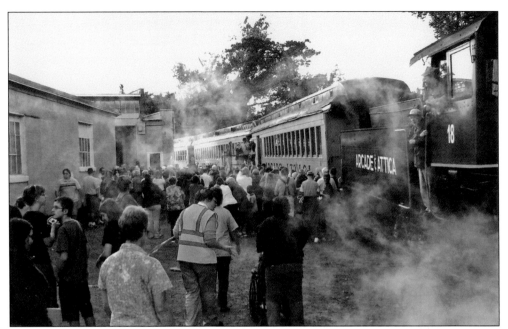

Engineer Brad Mapes is looking out over the large crowd at the Arcade and Attica Railroad train station in Arcade as wheelchair guests are being carefully lifted into the newly renovated passenger combine car for the special *Extreme Makeover: Home Edition* train on September 18, 2008. (Photograph by Patrick D. Connors.)

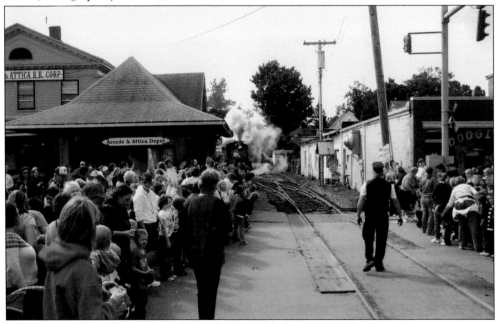

Arcade and Attica Railroad conductor Dean Steffenhagen is at the Main Street crossing as children from the Pioneer Elementary School in Arcade are ready to cheer for the *Extreme Makeover* train on September 18, 2008. It was amazing to witness the community turnout marking the completion of the program to make the railroad handicapped accessible. (Photograph by Patrick D. Connors.)

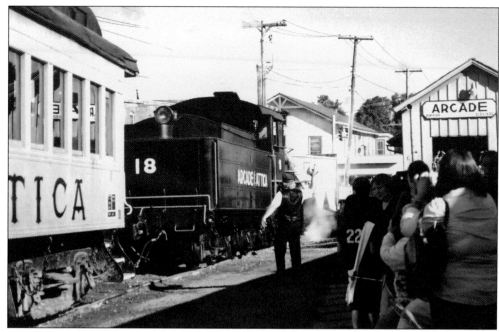

Arcade and Attica Railroad steam locomotive No. 18 backs up to couple onto combination passenger baggage car No. 309 on the September 18, 2008, train for the ABC television show *Extreme Makeover: Home Edition.* The railroad completed modifications to two passenger cars to make them handicapped accessible. Members of the Christian Youth Corps headed by Pete Andrews painted the exterior of the train station. (Photograph by Kenneth C. Springirth.)

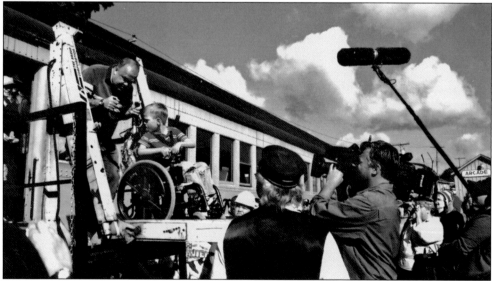

September 18, 2008, marks the completion of the program to make the Arcade and Attica Railroad handicapped accessible. With the acquisition of a special lift, handicapped children in wheelchairs can now be loaded on the special modified passenger cars. An incredible amount of community support drew a large crowd of residents and volunteers to the station. (Photograph by Kenneth C. Springirth.)

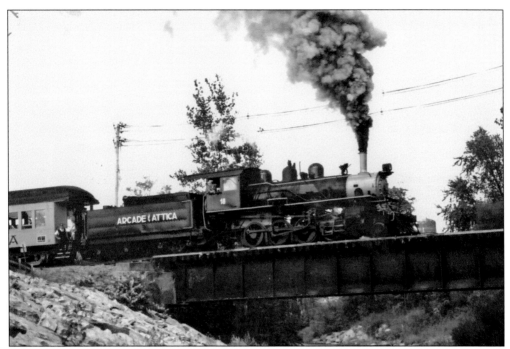

On September 18, 2008, Arcade and Attica Railroad locomotive No. 18 is crossing Cattaraugus Creek northbound for Curriers. The locomotive had been built 88 years ago in 1920 with 50-inch-diameter drive wheels, an empty weight of 122,500 pounds, and a tractive effort of 28,400 pounds, which is the force that a locomotive can apply to its coupler to pull a train. (Photograph by Kenneth C. Springirth.)

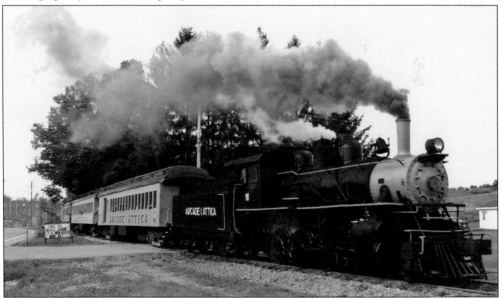

Near Curriers Road on September 18, 2008, Arcade and Attica Railroad locomotive No. 18 is paused for a photograph stop, hauling coaches Nos. 309, 311, 312, 305, 307, and a gondola car for passengers who prefer the open air. North of Arcade, the seven-mile trip to Curriers is in farm country. (Photograph by Patrick D. Connors.)

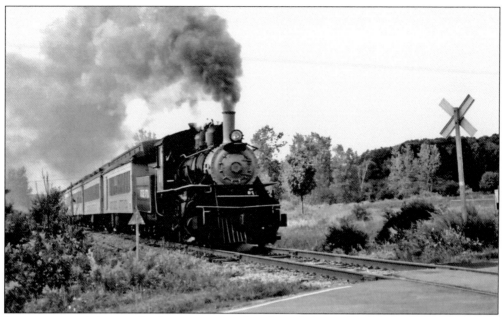

In a scene reminiscent of a long-gone era, Arcade and Attica Railroad locomotive No. 18 approaches Genesee Road on a northbound trip to Curriers on September 18, 2008. From this point to Curriers, the line enters the sylvan valley along Monkey Run Creek and is very isolated from public roads. (Photograph by Kenneth C. Springirth.)

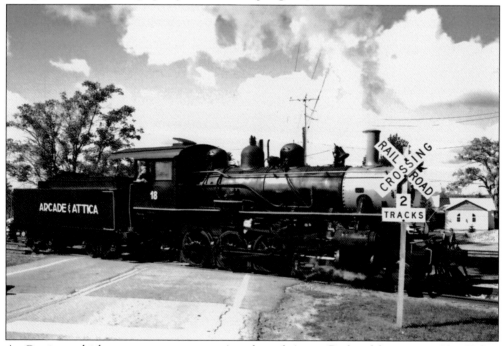

At Curriers, which serves as a rest stop, Arcade and Attica Railroad locomotive No. 18 has backed around the train via the passing siding and is crossing Chaffee Road at Curriers to couple up to the train for the return trip to Arcade on September 18, 2008. (Photograph by Kenneth C. Springirth.)

Jon Thomas Robertson, the young boy from Cuba, New York, who with the help of his friends has treated hundreds of special children to train rides by recycling pop cans for money to buy train tickets, is holding the sign, "Thank You ABC Good Morning America." Robertson and his mother Monica Simons contacted *Extreme Makeover: Home Edition* to help make the railroad handicapped accessible. (Photograph by Kenneth C. Springirth.)

Sam Kish, Arcade and Attica Railroad conductor, is preparing to flag the special train (commemorating the railroad becoming handicapped accessible) across Main Street in Arcade for the end of the run at the Arcade passenger station on September 18, 2008. The dedication of the railroad management, employees, and area volunteers to complete this project was another example of why this railroad and community are special. (Photograph by Kenneth C. Springirth.)

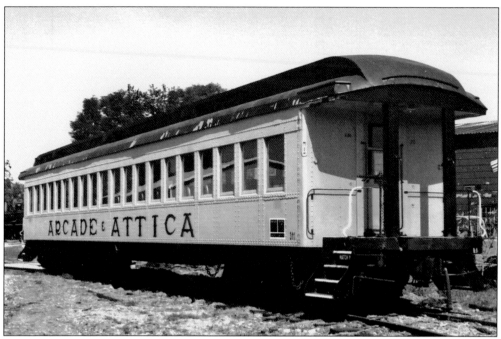

Arcade and Attica Railroad passenger car No. 311 is at Arcade near the engine house on September 24, 2008. Pullman Car Company built this in 1914, making it 94 years old in 2008. It was acquired from the Delaware, Lackawanna and Western Railroad as No. 552 in 1972. (Photograph by Kenneth C. Springirth.)

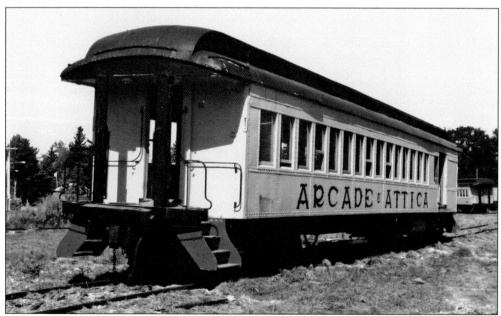

Combination passenger and baggage car No. 306 is at Arcade on September 24, 2008. Built by Pullman Car Company in 1917, the Arcade and Attica Railroad purchased this car from the Delaware, Lackawanna and Western Railroad as No. 424 during 1962. With windows that open, this car provided natural climate control. (Photograph by Kenneth C. Springirth.)

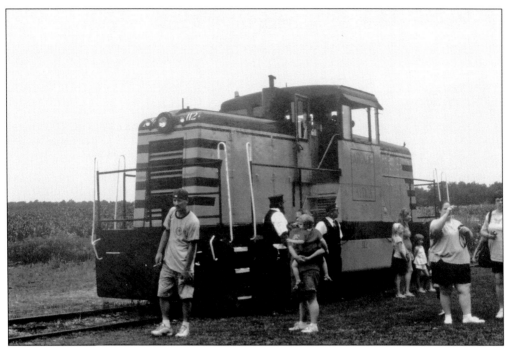

Arcade and Attica Railroad locomotive No. 112 is at the siding at Curriers during a layover on July 23, 2008. This afforded visitors an opportunity to view the locomotive and ask the crew questions before it moved to the other end of the train for the trip back to Arcade. (Photograph by Kenneth C. Springirth.)

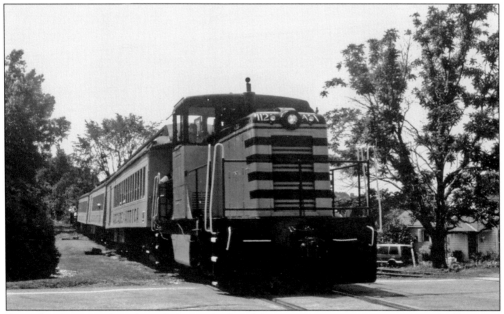

On July 23, 2008, Arcade and Attica Railroad locomotive No. 112 is crossing Chaffee Road to pull into Curriers station, the northern terminus of this excursion. Located about 40 miles southeast of Buffalo, the train was a popular destination point for visitors in the beautiful rolling hills of Wyoming County. (Photograph by Kenneth C. Springirth.)

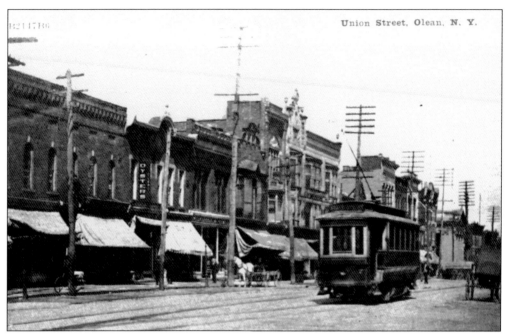

In this postcard postmarked August 7, 1912, Olean Street Railway Company trolley car No. 7 is on Union Street in Olean. While Arcade did not have a trolley line, it was a quick train trip via the Pennsylvania Railroad from Arcade to Olean. Electric trolley car service began in Olean on June 20, 1893. It became the Western New York and Pennsylvania Traction Company on November 17, 1906.

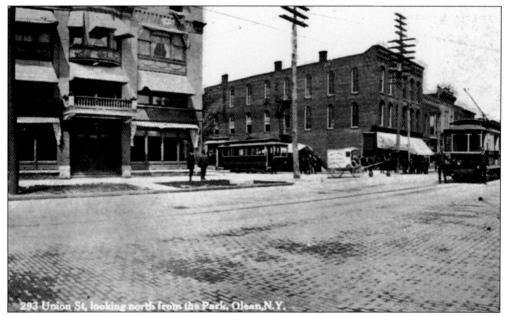

Two Olean Street Railway Company trolley cars are at Union Street looking north from the park in Olean. In 1918, the system operated 55 trolley cars on a 99-mile system that operated in New York State and Pennsylvania. It reorganized in 1921 as the Olean, Bradford and Salamanca Railway Company. At midnight on September 1, 1927, trolley car service ended on this system.

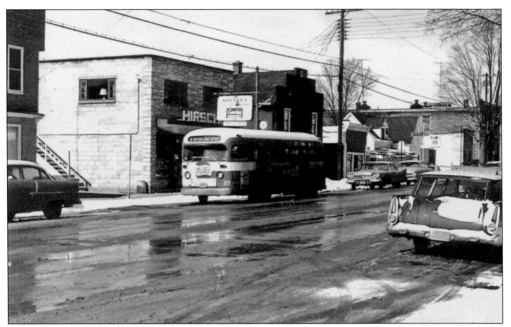

Blue Bird Coach Lines, Inc., bus No. 117 is a General Motors model TGH-3102, built during 1953 with a seating capacity of 30. There were two bus routes in Olean: an Olean city loop and a route to East Olean. Bus service operated in Olean since August 1925 when the Olean, Bradford and Salamanca Railway Company operated bus service along with its trolley car service. (Motor Bus Society Library collection.)

Bus No. 521 is a General Motors model TDH-4519, part of Blue Bird Coach Lines, Inc., series 509 to 533 built during 1966, seating 45 passengers. The company headquartered in Olean had an excellent reputation for its equipment appearance and service. (Motor Bus Society Library collection.)

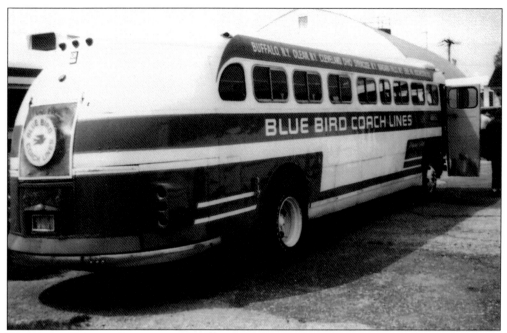

The General Motors Corporation Truck and Coach Division of Pontiac, Michigan, during 1947 built this bus model PD-3703-016 with a four-cylinder diesel engine model 4-71. This bus was used on the Buffalo via Arcade to Olean line operated by Blue Bird Coach Lines, Inc. Starting with local bus service in Olean during 1941, by the early 1960s, the company had charter rights in 48 states. (Motor Bus Society Library collection.)

The April 28, 1974, Blue Bird Coach Lines, Inc., bus timetable shows local service from Buffalo via Arcade to Olean and Bradford. The Olean–Buffalo line was acquired from Greyhound, and by 1963 operated service to Bradford, Pennsylvania. (Courtesy of Louis A. Magnano, president and chief executive officer of Park Centre Development, Inc.)

PICK UP POINTS	MONDAY-SATURDAY LINE RUN				SUNDAYS-HOLIDAYS	
OLEAN Barry St. (Casino Customer Boarding)	LV 7:30AM	—	—	AR 8:00 PM	LV 9:30 AM	AR 8:55PM
△ OLEAN Blue Bird Sq. (Buffalo Customer Boarding)	7:35AM	AR 1:05PM	LV 2:40PM	7:55 PM	9:35AM	8:50PM
Hinsdale	f	f	f	f	f	f
Maplehurst	f	f	f	f	f	f
Ischua	f	f	f	f	f	f
Franklinville	f 7:56 AM	f 12:33 PM	f 3:06 PM	f 7:26 PM	f 9:56 AM	f 8:26 PM
△ MACHIAS	8:05 AM	12:22 PM	3:16 PM	7:16 PM	10:06 AM	8:16 PM
Delevan	f 8:16 AM	f 12:13 PM	f 3:26 PM	f 7:06 PM	f 10:16 AM	f 8:06 PM
Yorkshire	f	f	f	f	f	f
△ ARCADE	8:26 AM	12:03 PM	3:36 PM	7:01 PM	10:26 AM	8:01 PM
Yorkshire (Earl's)	8:35 AM	f	f	6:57 PM	10:35 AM	7:55 PM
Chaffee	f 8:40 AM	f 11:49 AM	f 3:50 PM	f 6:53 PM	f 10:40 AM	f 7:53 PM
△ HOLLAND	8:48 AM	11:37 AM	3:58 PM	6:45 PM	10:48 AM	7:45 PM
△ EAST AURORA	9:08 AM	11:21 AM	4:18 PM	6:25 PM	11:08 AM	7:25 PM
Galleria Mall	f 9:30 AM	f 10:51 AM	f 4:40 PM	f 6:00 PM	f 11:30 AM	f 7:00 PM
Radisson* (transfer) CONNECTING SERVICE TO	9:45 AM	—	—	5:45 PM	11:45 AM	6:45 PM

The January 20, 1997, Blue Bird Coach Lines, Inc., bus schedule on the Buffalo via Arcade to Olean line shows service to Buffalo and Galleria Mall. Under Louis A. Magnano, the company became the largest charter bus service in western New York and northwestern Pennsylvania. The company's theme was "Everybody goes first class." (Courtesy of Louis A. Magnano, president and chief executive officer of Park Centre Development, Inc.)

PICK UP POINTS	MONDAY – FRIDAY						SATURDAY				SUNDAY & HOLIDAY	
	LV 5:15A	AR 9:45A	LV 10:15A	AR 3:15P	LV 3:30P	AR 8:30P	LV 7:35A	AR 12:50P	LV 1:30P	AR 7:00P	LV 3:00P	AR 8:30P
⊚ OLEAN 301 South Union	LV 5:15A	AR 9:45A	LV 10:15A	AR 3:15P	LV 3:30P	AR 8:30P	LV 7:35A	AR 12:50P	LV 1:30P	AR 7:00P	LV 3:00P	AR 8:30P
HINSDALE	F	F	F	F	F	F	F	F	F	F	F	F
MAPLEHURST	F	F	F	F	F	F	F	F	F	F	F	F
ISCHUA	F	F	F	F	F	F	F	F	F	F	F	F
FRANKLINVILLE	5:40A	9:20A	10:40A	2:50P	3:55P	7:55P	8:00A	12:25P	1:55P	6:25P	3:25P	8:05P
⊚ MACHIAS	5:50A	9:10A	10:50A	2:40P	4:05P	7:45P	8:10A	12:15P	2:05P	6:15P	3:35P	7:55P
DELEVAN	F	F	F	F	F	F	F	F	F	F	F	F
LIMELAKE	F	F	F	F	F	F	F	F	F	F	F	F
⊚ ARCADE	6:10A	8:50A	11:10A	2:20P	4:20P	7:30P	8:30A	11:55A	2:25P	5:55P	3:55P	7:35P
YORKSHIRE	F	F	F	F	F	F	F	F	F	F	F	F
CHAFFEE	F	F	F	F	F	F	F	F	F	F	F	F
⊚ HOLLAND	6:30A	8:30A	11:30A	2:00P	4:40P	7:10P	8:50A	11:35A	2:45P	5:35P	4:15P	7:15P
S WALES	F	F	F	F	F	F	F	F	F	F	F	F
⊚ EAST AURORA	6:45A	8:15A	11:45A	1:45P	4:55P	6:55P	9:05A	11:20A	3:00P	5:20P	4:30P	7:00P
GALLERIA	N/S	N/S	N/S	N/S	N/S	N/S	9:35A	10:50A	3:30P	4:50P	4:45P	6:20P
BUFFALO AIRPORT	N/S	7:45A	N/S	N/S	5:25P	N/S	9:50A	10:35A	3:40P	4:45P	5:00P	6:15P
⊚ DOWNTOWN BUFFALO	AR 7:15A	LV 7:30A	AR 12:15P	LV 1:00P	AR 5:40P	LV 6:30P	AR 10:05A	LV 10:20A	AR 4:00P	LV 4:30P	AR 5:15P	LV 6:00P

⊚ Agency station which baggage may be checked and interline package express may be consigned.

F – Flag Stop-Passenger must stand where the driver can see them and flag the bus down. No ticket sales at these locations, purchase ticket from driver.

Sunday & Holiday Service: Consist of only one round trip beginning in Olean at 3:00P and departing Buffalo at 6:00P. New Year's Day, Easter, Memorial Day, 4th of July, Labor Day, Thanksgiving and Christmas.

COACH USA TICKET AGENCIES

Arcade, NY
Arcade & Attica RR 492-3100
Buffalo, NY
Metro Trans Center 800-231-2222
East Aurora, NY
Kelsey's Jewelers 652-0480

Holland, NY
Holland Pharmacy 537-2822
Machias, NY
Lil's Deli 353-4607
Olean, NY
Coach USA Terminal 372-5500

PICK UP LOCATIONS:
Airport Metro Bus Area
Galleria Bon Ton East Entrance
Olean – 301 South Union, Olean, NY

Bus service is operated by Coach USA Western New York with the schedule effective June 7, 2006, providing three round-trips Monday through Friday, two round-trips on Saturday, and one round-trip on Sunday and holidays from Buffalo via Arcade to Olean. The Arcade and Attica Railroad station in Arcade serves as the bus station. Arcade originally had connection with the outside world by railroad and today by bus.

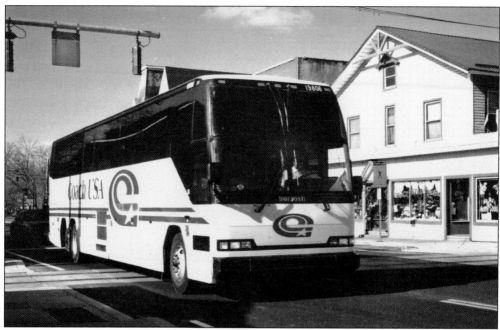

Coach USA bus No. 19806 is crossing the Arcade and Attica Railroad track on Main Street in Arcade preparing to make the 11:10 a.m. stop at the Arcade and Attica Railroad station on its trip to Buffalo on November 7, 2008. This 56-passenger bus model H3-45 was built by Prevost of Quebec, Canada, during 1998 for Blue Bird Coach Lines, Inc. (Photograph by Kenneth C. Springirth.)

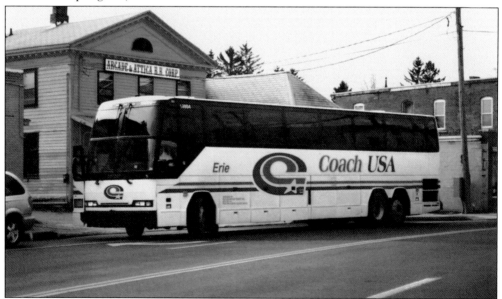

On November 14, 2008, Coach USA bus No. 19804 is making a passenger stop at the Federal-style (note upper fanlight) Arcade and Attica Railroad station on Main Street in Arcade. This model H3-45 bus was acquired from Blue Bird Coach Lines, Inc., during 1999. The bus was designed with a contoured two-piece windshield to enhance visibility for the driver and passengers. (Photograph by Kenneth C. Springirth.)

The front cover of the 2009 Arcade and Attica Railroad brochure welcomes riders to step back in time "aboard the train to yesterday." The adult round-trip ticket on the right-hand side was issued on August 29, 1963, and noted that the railroad was full sized with the trip made possible by the planning and work of the board of directors and employees. The *Arcade Herald* newspaper of June 24, 1993, reported that the one millionth passenger rode the Arcade and Attica Railroad, noting, "Mark Gaudioso of Rochester became the lucky recipient of a basketful of gifts presented to him at the A&A RR Curriers Station by Frank Conroy, vice president of the railroad's board of directors." That was the railroad's 31st year of providing steam excursion trips. (Courtesy of Arcade and Attica Railroad.)

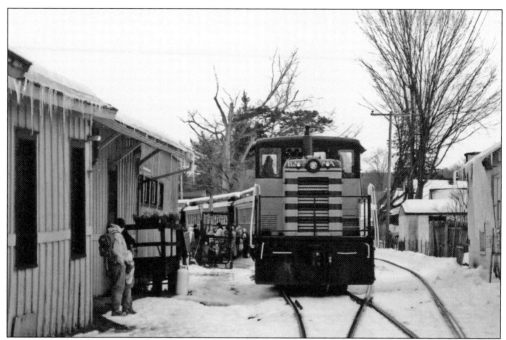

A wintry December 14, 2008, finds Arcade and Attica Railroad locomotive No. 112 waiting departure time as passengers board the train. The railroad purchased the present Main Street train station in 1900. Originally, part of the building was built as a private home around 1830. (Photograph by Kenneth C. Springirth.)

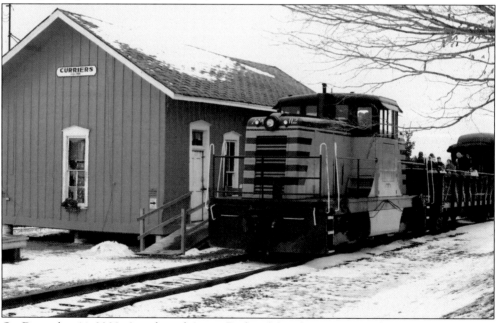

On December 14, 2008, Arcade and Attica Railroad diesel No. 112 is ready to leave Curriers for its southbound trip to Arcade. Inside this historic station are a number of historic photographs on the railroad. This station serves as the turnaround point for the passenger excursions and has prominently stood there since 1881. (Photograph by Kenneth C. Springirth.)

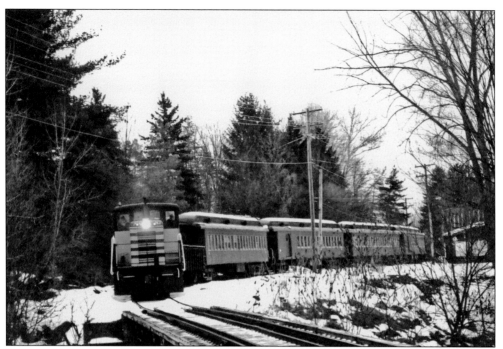

The southbound Arcade and Attica Railroad train pulled by diesel No. 112 is about to cross Cattaraugus Creek on a snow-covered December 14, 2008. The railroad operated a number of trains, each one denoted as the "North Pole Express," during December to help riders enjoy Christmas on the rails. (Photograph by Kenneth C. Springirth.)

Trudy Ling, wife of general manager George Ling, is hard at work doing a multitude of tasks at her desk at the Arcade and Attica Railroad station on May 13, 2009. This railroad has withstood all kinds of challenges. Management and employees have made the extra effort to preserve this lifeline for Wyoming County. (Photograph by Kenneth C. Springirth.)

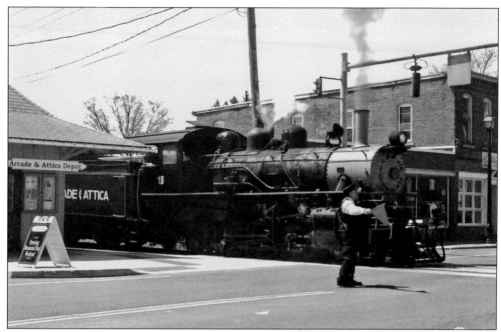

Arcade and Attica Railroad general manager George Ling is flagging the Main Street crossing for locomotive No. 18 for Buffalo public broadcasting television station WNED filming *Western New York A to Z* on May 13, 2009. There are a number of attractions in western New York. The Arcade and Attica Railroad is generally listed first in alphabetical order. (Photograph by Kenneth C. Springirth.)

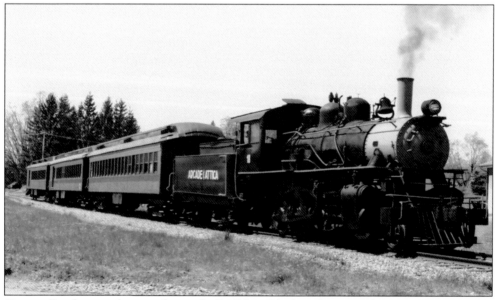

Curriers Road was a photograph stop for Buffalo public broadcasting television station WNED filming *Western New York A to Z* on May 13, 2009. The television crew spent many hours photographing the railroad to give viewers a complete look at the railroad. To enhance the railroad's historical significance, the passenger cars have been repainted Laurel Woods Green. (Photograph by Kenneth C. Springirth.)

Three

FREIGHT SERVICE

When the Buffalo and Susquehanna Railway (which obtained ownership of the Buffalo, Attica and Arcade Railroad) suspended operations, there was concern that the railroad from Arcade to Attica would be abandoned. Local investors formed the Arcade and Attica Railroad to purchase the Buffalo, Attica and Arcade Railroad and maintained service from Arcade to Attica. The railroad survived the hard economic times of the 1930s. From Moody's *Manual of Investments American and Foreign Railroad Securities* from 1932, operating revenues decreased from $126,367 in 1926 to $94,134 in 1931, while operating expenses were reduced from $105,448 in 1926 to $76,283 in 1931. Net income was $228 in 1926 and was $3,615 in 1931. As a result of severe flooding, the line from North Java to Attica was abandoned in 1957 with the railroad losing its freight business with the Attica State Prison. On the surviving section from Arcade to North Java, the railroad carried soybeans, corn, fertilizer, lumber, and dairy feed. At the April 4, 1970, annual Arcade and Attica Railroad stockholders meeting, it was reported that during 1969 an average of 200 carloads of freight a month were handled, which set a new record. A 20 percent increase in freight revenues occurred because of new industries in the area and expansion of existing plants. During 1970, the railroad purchased 13 special-duty boxcars from the Baltimore and Ohio Railroad for use by the Borden Company for shipping its new product Cremora, which was produced at the Arcade plant of the Borden Company. The cars were renovated, lined with laminated fiberglass plywood, and painted orange with black lettering. This resulted in increased business for the railroad. However, on December 31, 1970, the Borden plant at Arcade closed, and the railroad later abandoned the spur track to the plant.

In 2009, the railroad's main shipper is Reisdorf Brothers Feed Mill at North Java. Diesel locomotive No. 112, purchased in 1988 from Colorado Springs, is the primary freight power, and diesel No. 111 is used when additional power is needed. The railroad connects with the Buffalo and Pittsburgh Railroad at Arcade, which leases trackage from the Norfolk Southern Railway from Machias Junction to Buffalo providing access to the national railroad network. Arcade has a large industrial base, nearby state-of-the-art farms, and a revitalized downtown business district whose hardworking residents have a tremendous fondness for their community. Arcade is on the right track with the Arcade and Attica Railroad.

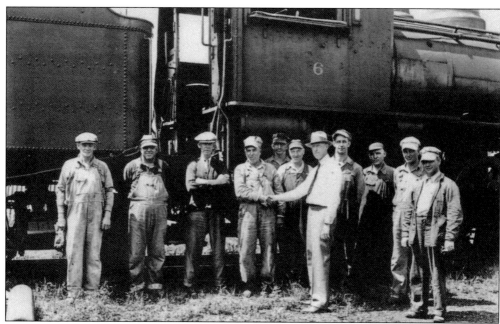

The Arcade and Attica Railroad crew is seen in 1936 for the retirement of Lavern Wagner. From left to right are Gus Berwanger, Rube Roblee, Earl Dean, Laverne Wagner, Dan Roblee, John Gubbins, Richard I. Cartwright, Bud King, Al Hurd, Maurice Hopkins, and Howard Hopkins. (Arcade Historical Society collection.)

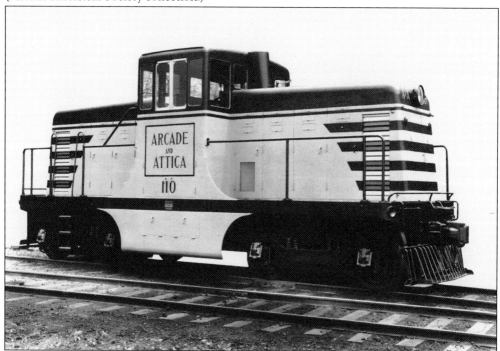

The first diesel unit on the Arcade and Attica Railroad is No. 110, built in 1941 by General Electric Company in Erie, Pennsylvania, at a cost of $36,000. This locomotive is now on display at the Arcade municipal parking lot. (Arcade and Attica Railroad collection.)

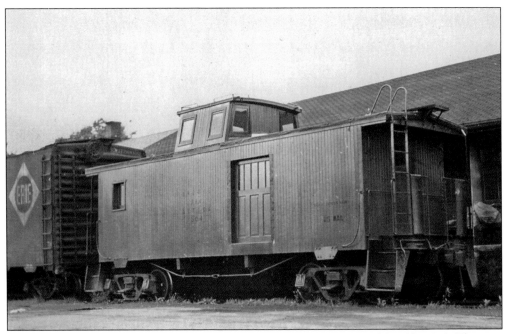

Arcade and Attica Railroad caboose No. 304 is at Attica station on May 23, 1949. This was originally Erie Railroad caboose No. 04923. The cupola, which is the small windowed projection on the roof where the crew sits to view the train for any problems, was later removed by the shop crew of the Arcade and Attica Railroad. (Patrick D. Connors collection.)

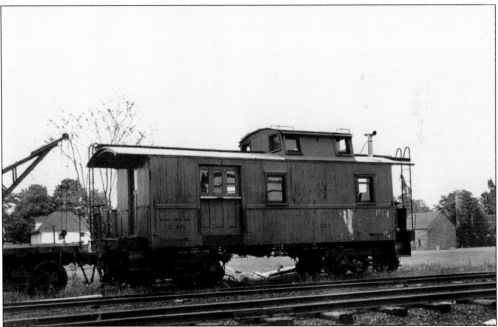

On June 2, 1950, Arcade and Attica Railroad caboose No. 303 is at the Arcade shop. To the left is a maintenance of way crane car that was on the property until the late 1960s. The caboose was later restored by E. R. Rule and was placed on display in the Arcade municipal parking lot by the Friends of the Arcade and Attica Railroad, Inc. (Patrick D. Connors collection.)

A section car has just crossed Chaffee Road heading northbound on November 2, 1965. Between Genesee Road and Chaffee Road, the line is isolated in the Monkey Run Creek valley with no public road crossings from either Curriers Road on the west or New York State Route 98 on the east. (Photograph by Kenneth C. Springirth.)

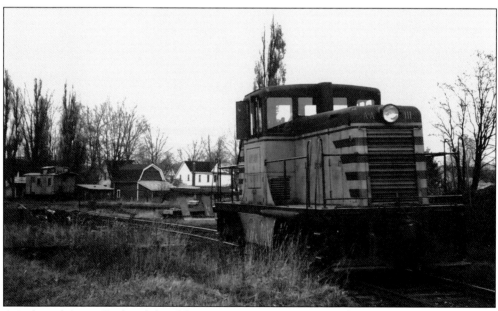

Arcade and Attica Railroad diesel locomotive No. 111 is in Arcade on November 2, 1965. On the left of the picture, caboose No. 303, formerly No. 15 of the Susquehanna and New York Railroad, is in view. The Susquehanna and New York Railroad operated from the Lehigh Valley Railroad at Towanda, Pennsylvania, to the Pennsylvania Railroad at Marsh Hill, Pennsylvania, until abandonment in 1942. (Photograph by Kenneth C. Springirth.).

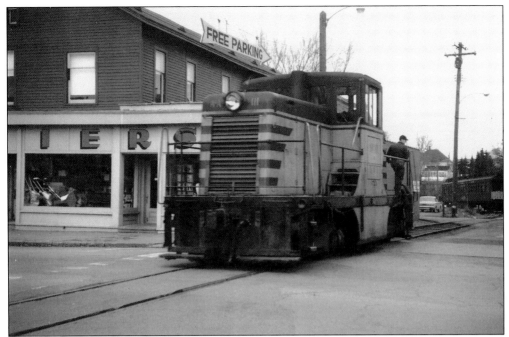

Arcade and Attica Railroad diesel No. 111 is crossing Main Street in Arcade on November 2, 1965. New York, Ontario and Western Railroad car No. 30, *Warwick*, can be seen on the right side of the picture in the municipal parking lot behind the downtown business district. (Photograph by Kenneth C. Springirth.)

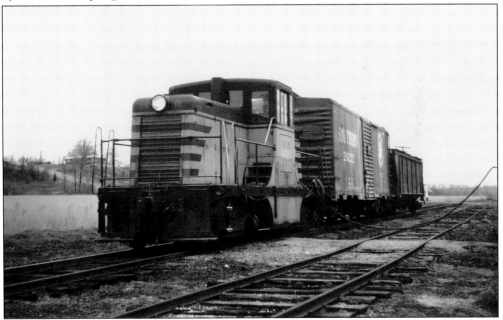

Arcade and Attica Railroad locomotive No. 111 is refueling on a southbound run from North Java to Arcade on November 2, 1965. Before the 1957 washout, the line connected with the Erie Railroad at Attica and handled switching duties at the Attica State Prison where this type of locomotive could handle tight clearances. (Photograph by Kenneth C. Springirth.)

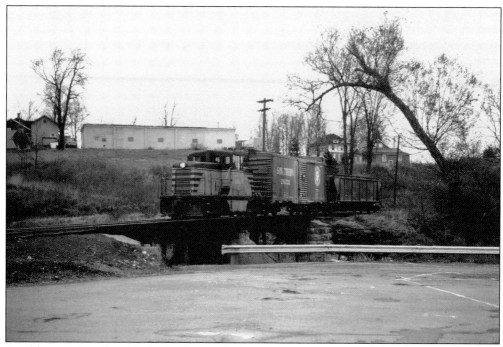

Southbound Arcade and Attica Railroad diesel No. 111 is crossing Cattaraugus Creek on November 2, 1965. General Electric Company at Erie, Pennsylvania, built this 44-ton, 380-horsepower locomotive in 1947 for the railroad, and 62 years later the locomotive is still in service in 2009. The railroad purchased its first diesel, No. 110, in 1941. (Photograph by Kenneth C. Springirth.)

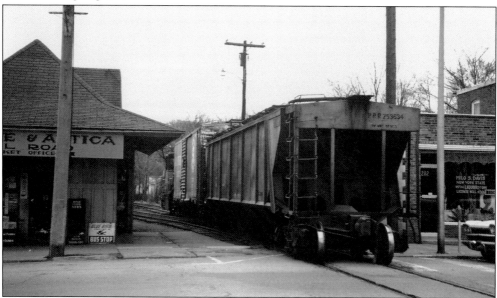

The southbound freight with locomotive No. 111 from North Java is crossing Main Street in Arcade and is passing the Arcade and Attica Railroad corporate office and station on November 2, 1965. Having an independent railroad serving Arcade has helped to keep the community on the right track. (Photograph by Kenneth C. Springirth.)

In the winter snow of March 1966 near Prospect Street in Arcade behind what is today the Prestolite plant, Arcade and Attica Railroad diesel No. 110 is handling a freight assignment. Operating in all kinds of weather, the railroad benefited farmers by lowering feed and fertilizer prices made possible by bulk-rail service. (Cecil A. Lester collection.)

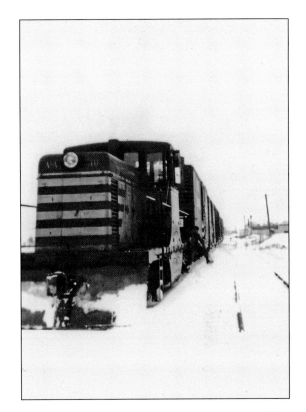

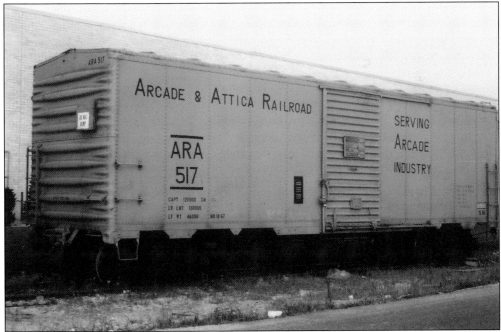

Serving Arcade industry, Arcade and Attica Railroad boxcar No. 517 is on the siding. This was one of a series of boxcars numbered 510 to 523, originally built for the New Haven Railroad, acquired in the 1960s, and sold around 1974. (Arcade and Attica Railroad collection.)

In Arcade in June 1970, Arcade and Attica Railroad diesel No. 111 is pulling Western Maryland Railroad (merged with the Baltimore and Ohio Railroad in 1983) hopper car No. 1056 and Chicago Burlington and Quincy Railroad (merged with Great Northern Railway, Northern Pacific Railway, and Spokane Portland and Seattle Railway on March 2, 1970, into the Burlington Northern Railroad) boxcar No. 40222. (Photograph by Ken Kraemer, Chris Lester collection.)

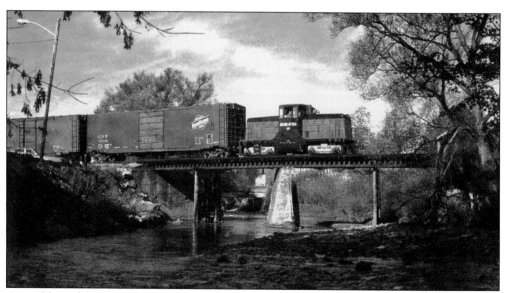

A northbound freight train, powered by Arcade and Attica Railroad diesel locomotive No. 110, is crossing the trestle over picturesque Cattaraugus Creek. Boxcar No. 37050 behind the locomotive was from the Chicago Northwestern Railway, which was purchased in April 1995 by the Union Pacific Railroad. (Arcade and Attica Railroad collection.)

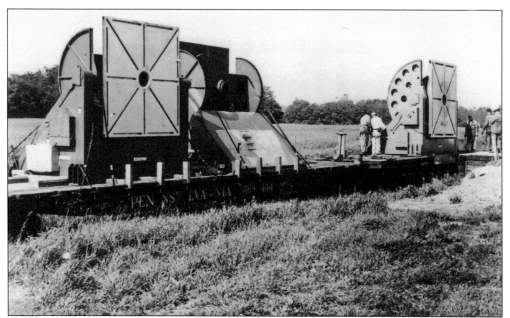

A 24-ton giant "positioner," built by Aronson Machine Company of Arcade, is being shipped to Babcock and Wilcox Company of Barberton, Ohio, via the Arcade and Attica Railroad and the Pennsylvania Railroad. (Arcade and Attica Railroad collection.)

Arcade and Attica Railroad steel boxcars No. 501 and No. 502 are at the Borden plant at Arcade around 1970. These were leased boxcars that were originally built in the 1950s. (Arcade and Attica Railroad collection.)

On July 15, 1972, the Arcade and Attica Railroad snowplow is at Arcade awaiting winter, which brings heavy snowfall in this region. The plow was pushed by a diesel locomotive to open the line after a snowstorm. In a heavy snowdrift, the plow was backed up and then would plow through. (Photograph by Kenneth C. Springirth.)

Consolidated Rail Corporation diesel locomotives built by the Electro-Motive Division of General Motors Corporation No. 6394 (3,000-horsepower six-axle type SD40-2) and No. 8055 (2,000-horsepower four-axle type GP38-2) are switching freight cars on the interchange trackage near the Blue Seal plant in Arcade on October 19, 1997. (Photograph by Jeffrey C. Mason; Arcade town historian collection.)

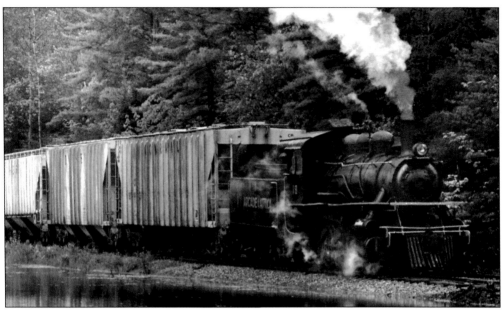

A special mixed train is northbound to North Java passing by the reflecting pond near the Beaver Meadow Audubon Center on May 27, 1992. Small streams border much of the railroad line. At times, beavers plug the drainage culverts under the rail embankment to create ponds, which sometimes get large enough to washout the tracks. (Photograph by Ken Kraemer.)

STATEMENT OF DEMURRAGE CHARGES

N. Y. _____ 19___

Misc. Rev. No . _____

To - ARCADE & ATTICA RAILROAD CORP., Dr.

For Car Demurrage Charges as per following itemized statement:

CAR		ARRIVED		ORDERED OR NOTICE SENT OR GIVEN		CONSTRUCTIVELY PLACED		ACTUALLY PLACED		RELEASED		DAYS DETENTION	AMOUNT
INITIALS	NUMBER	DATE	HOUR	DATE	HOUR	DATE	HOUR	DATE	HOUR	DATE	HOUR		

For Car Demurrage Charges, in accordance with Average Agreement between above-named party and the A. & A. R. R. Corp. as follows:

STATEMENT FOR THE MONTH OF: _____ 19___

	NUMBER OF CARS RELEASED	NUMBER OF DEBITS	NUMBER OF CREDITS	DEBITS IN EXCESS OF CREDITS	AMOUNT CHARGED ON EXCESS DEBITS	AMOUNT CHARGED AFTER DEBIT PERIOD	TOTAL AMOUNT
INBOUND							
OUTBOUND							

Please compare with your records. The above exhibit of our records will be considered to have been acknowledged by you to be correct unless written notice of any exceptions thereto is given us within ten days after receipt of bill.

Received Payment for the Corporation 19 ___

Just like the big railroads, the Arcade and Attica Railroad uses a form to collect demurrage charges. Demurrage is a charge assessed by the railroad when a customer uses an excessive amount of time to load or unload a car. This helps load or unload cars quickly and helps offset car hire cost. It also includes charges for storing empty cars assigned to customers. (Arcade and Attica Railroad collection.)

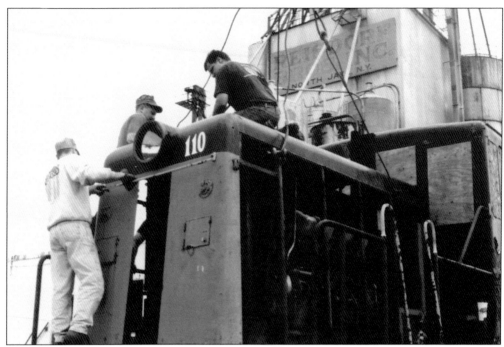

The diesel engine is in the process of being replaced on Arcade and Attica Railroad diesel locomotive No. 110 at Reisdorf Brothers Feed Mill at North Java around June 1996. (Arcade and Attica Railroad collection.)

Reisdorf Brothers Feed Mill at North Java is the scene for the change out of the diesel engine on locomotive No. 110 around June 1996. (Arcade and Attica Railroad collection.)

Workers are preparing to lift off the hood covering the diesel engine on Arcade and Attica Railroad locomotive No. 110 at Reisdorf Brothers Feed Mill at North Java around 1996. (Arcade and Attica Railroad collection.)

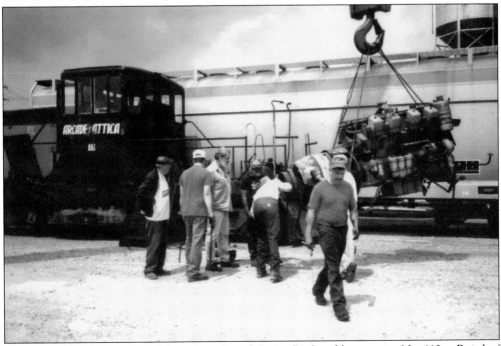

The engine has been removed from Arcade and Attica Railroad locomotive No. 110 at Reisdorf Brothers Feed Mill at North Java during June 1996. (Arcade and Attica Railroad collection.)

Arcade and Attica Railroad diesel locomotive No. 112 is northbound crossing Beaver Meadow Road near Java Center on April 13, 2003. This locomotive was the primary workhorse on the railroad with slightly more horsepower, more weight, and more tractive effort than the railroad's other diesel No. 111. In the beginning all railroads were short lines, but most early railroads combined to form larger systems. The Arcade and Attica Railroad began as a short line and has continued as a short-line railroad. Merger and growth was the dominant trend in the railroad industry until the June 21, 1970, bankruptcy of the Penn Central Transportation Company, which resulted in the formation of the Consolidated Rail Corporation followed by a proliferation of short-line railroads. The Arcade and Attica Railroad survived by hard work and a responsive local management that realizes the railroad provides great economic value to the region it serves. (Photograph by Kenneth Lehman.)

Two covered hopper cars are being pulled by Arcade and Attica Railroad diesel No. 112 northbound passing the reflecting pond south of the Welch Road crossing on April 13, 2003. Many of the ponds in this region were not from a glacial leftover but were engineered by beavers who chiseled down trees, which provided the raw material to build a dam and beaver lodge. Beavers are busy for the most part working during the night on their projects. There has been a history of uncontrolled ponds in the wrong area undermining railroad trackage. At North Java, the railroad's main freight customer, Reisdorf Brothers Feed Mill, is the only source of freight traffic at the northern end of the line. The Arcade and Attica Railroad is unusual in that most steam excursion lines carry no freight and only a few privately owned railroads still carry passengers. This is not just a steam excursion line but is a real working railroad. (Photograph by Kenneth Lehman.)

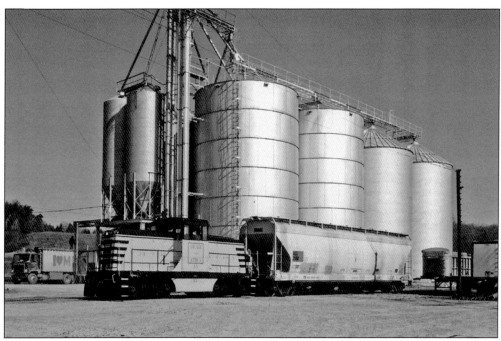

Arcade and Attica Railroad diesel No. 112 is switching at the Reisdorf Brothers Feed Mill at North Java on April 13, 2003. This is the railroad's main customer and is their only customer on the northern end of the line. (Photograph by Kenneth Lehman.)

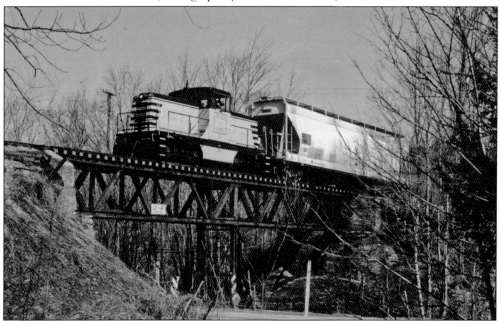

Southbound Arcade and Attica Railroad diesel No. 112 is crossing the trestle over Beaver Meadow Road near Java Center on April 13, 2003. As expenses of running the railroad increased and competing truck transportation cut into business, the diesel locomotive reduced operating expenses, which contributed to the continued operation of the railroad. (Photograph by Kenneth Lehman.)

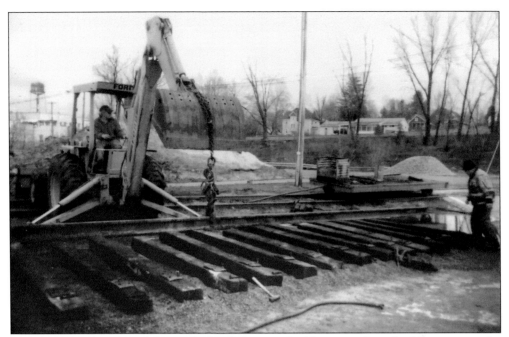

Friends of the Arcade and Attica Railroad, Inc., are building a track to display a train in the municipal parking lot in downtown Arcade during April 2008. This is a volunteer support group for the railroad that is preserving the historic antiquity of the railroad. (Photograph by Chris Lester.)

In April 2008, members of the Friends of the Arcade and Attica Railroad, Inc., working on the train display project, from left to right, are Chris Lester, Norm Patton, Patrick D. Connors, Richard Harrison, and Dave Copeland. (Photograph by Jon Patton.)

Chris Lester of the Friends of the Arcade and Attica Railroad, Inc., uses a spike puller to move the rail into position for the municipal parking lot train display trackage in April 2008. (Photograph by Patrick Burns.)

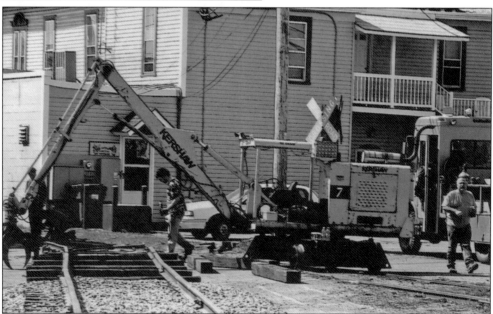

A temporary track connection is being prepared by the Friends of the Arcade and Attica Railroad, Inc., to move the rolling stock onto the new siding in the Arcade municipal parking lot during April 2008. The mission of the organization is to support the steam passenger operation of the Arcade and Attica Railroad. They have also updated pictures at Curriers station. (Photograph by Jon Patton.)

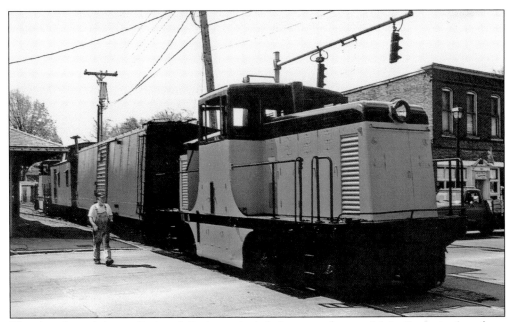

The Arcade and Attica Railroad display train is being moved across Main Street in Arcade to its new display at the municipal parking lot under the watchful eyes of Dave Copeland of the Friends of the Arcade and Attica Railroad, Inc. Diesel locomotive No. 110 made its first run on June 16, 1941, and was retired in 1996. (Photograph by Patrick Burns.)

Patrick D. Connors of the Friends of the Arcade and Attica Railroad, Inc., is checking to make sure the wheels remain on the track as the train is moved into position on the new display track at the Arcade municipal parking lot on April 26, 2008. (Photograph by Chris Lester.)

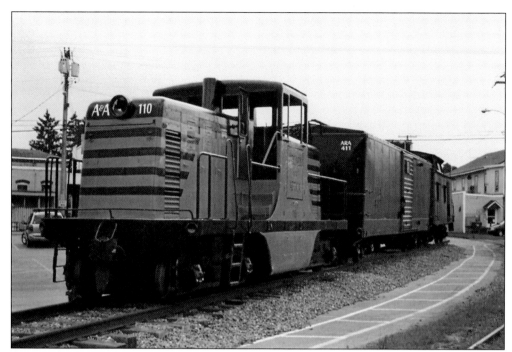

A static display has been set up in the downtown Arcade parking lot alongside the railroad line in this July 23, 2008, view consisting of the following Arcade and Attica Railroad equipment: diesel locomotive No. 110 (purchased new from the General Electric Company in 1941), boxcar No. 411, and caboose No. 303 (formerly Susquehanna and New York Railroad, No. 15, acquired in 1943). (Photograph by Kenneth C. Springirth.)

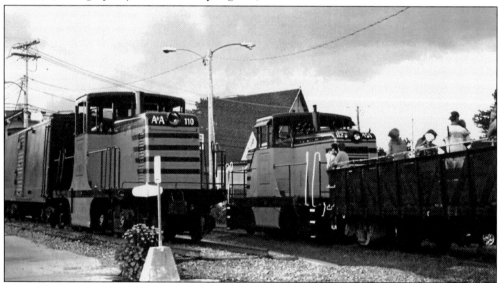

The afternoon excursion train of July 23, 2008, powered by Arcade and Attica Railroad locomotive No. 112, passes the Arcade parking lot display featuring locomotive No. 110, the railroad's first diesel. Locomotive No. 110 was powered by two Caterpillar model D17000 diesel engines that delivered long life, high availability, low maintenance cost, and low operating cost, as advertised. (Photograph by Kenneth C. Springirth.)

A massive track upgrading program is underway on the Arcade and Attica Railroad with a variety of equipment at Curriers on September 10, 2008. On the siding at the left, new ties are being installed. A tie was replaced if it could not maintain track gauge, track alignment, and was not able to distribute the load from the rail to the ballast. (Photograph by Kenneth C. Springirth.)

Much of today's track equipment is mechanized with the device lifting the tie from the stack to the appropriate position alongside the track at the historic Curriers station on September 10, 2008. This is the terminus for passenger service while freight service operates north to North Java. (Photograph by Kenneth C. Springirth.)

Track work on the Arcade and Attica Railroad at Curriers involves a number of items, including replacing ties. During the process, the gauge is checked, which is the distance between two rails measured at right angles to the rail at 0.625 inches below the top surface of the railhead. Even with today's specialized equipment, track work involves hard work. (Photograph by Kenneth C. Springirth.)

A new switch is installed on the Arcade and Attica Railroad south of Chaffee Road in Curriers on September 10, 2008. With new ties in place, tie plates were placed between the rail and tie to distribute the applied load from the rail to the tie and to keep the rail in place. The track upgrading enabled the railroad to handle today's heavier freight cars. (Photograph by Kenneth C. Springirth.)

Arcade and Attica Railroad general manager George Ling and his wife Trudy Ling, who handles public relations plus a variety of duties, are at Curriers, checking on the rail rehabilitation project on September 10, 2008. This was a major project that required careful planning to maintain freight and passenger excursion service. (Photograph by Kenneth C. Springirth.)

The Arcade and Attica Railroad crossing on Main Street in downtown Arcade is being rebuilt on September 24, 2008. New rail and concrete paving was completed on the eastbound lane, and workers were digging out rail and road materials on the westbound lane. This work was scheduled during the week and done in sections to maintain two-way traffic in this busy thoroughfare. (Photograph by Kenneth C. Springirth.)

Arcade and Attica Railroad locomotive No. 111 has backed freight cars on the siding at the interchange point with the Buffalo and Pittsburgh Railroad at Arcade Junction on September 12, 2008. The Pennsylvania Railroad operated through Arcade until merger with the New York Central Railroad created the Penn Central Transportation Company on February 1, 1968. That railroad filed for bankruptcy on June 21, 1970. (Photograph by Kenneth C. Springirth.)

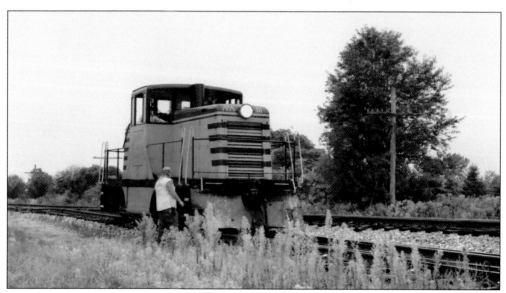

Arcade and Attica Railroad conductor Dennis Horner has set the switch for engineer Brad Mapes in locomotive No. 111 at Arcade Junction on September 12, 2008. Consolidated Rail Corporation was formed on April 1, 1976, to take over the Penn Central Transportation Company until June 1, 1999, when assets were sold to CSX Transportation and Norfolk Southern Railway obtained the line through Arcade. (Photograph by Kenneth C. Springirth.)

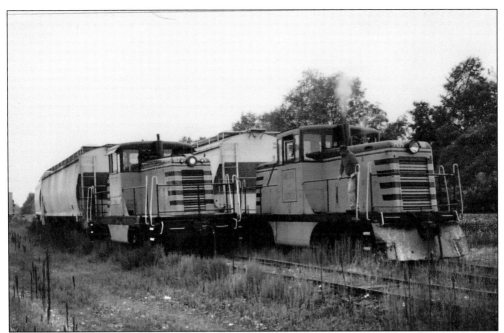

On September 12, 2008, the entire active diesel fleet of the Arcade and Attica Railroad is handling duties at the interchange with the Buffalo and Pittsburgh Railroad, which leases the trackage from Norfolk and Southern Railway. Sam Kish is standing on locomotive No. 111 while locomotive No. 112 is on the adjacent track. (Photograph by Kenneth C. Springirth.)

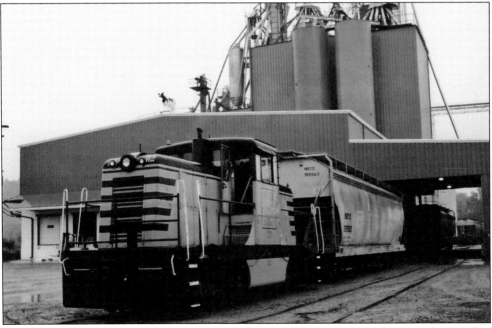

Arcade and Attica Railroad locomotive No. 112 is handling switching duties at the Reisdorf Brothers Feed Mill at North Java on September 12, 2008. Since 1957, this has been the northern terminus of the railroad. Over the years this feed mill has been an important freight customer for the railroad. (Photograph by Kenneth C. Springirth.)

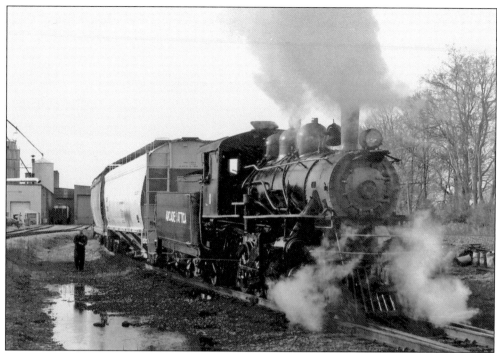

On October 27, 2008, Arcade and Attica Railroad locomotive No. 18 is ready to depart from Arcade Junction with a freight train. This is an excellent example of how the railroad uses its resources to highlight its steam program. Time has stood still on this railroad in a very positive manner. (Photograph by Patrick D. Connors.)

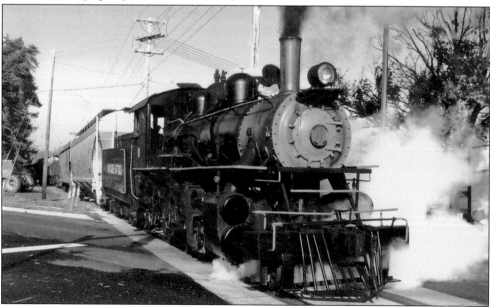

Arcade and Attica Railroad locomotive No. 18 is crossing West Main Street, which is New York State Route 39, with a northbound freight train just west of downtown Arcade on October 27, 2008. This was the only steam-powered freight train operating in New York State that day. (Photograph by Patrick D. Connors.)

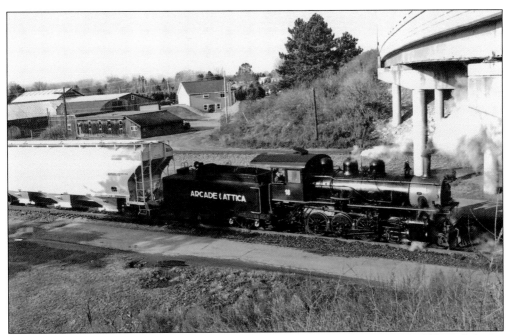

Heading under the New York State Route 39 bridge on October 27, 2008, Arcade and Attica Railroad locomotive No. 18 is powering the freight train leaving Arcade Junction, the interchange point with the Norfolk Southern Railway, which has leased that trackage to the Buffalo and Pittsburgh Railroad. (Photograph by Patrick D. Connors.)

Behind the former Agway mill in Arcade finds Arcade and Attica Railroad locomotive No. 18 handling a freight run on October 27, 2008. Scenes like this were once commonplace in the United States. This might take months to arrange on a major railroad, but the Arcade and Attica Railroad has a progressive management and skilled workforce that does extra things for a very special operation. (Photograph by Patrick D. Connors.)

Arcade and Attica Railroad locomotive No. 18 is passing behind the Prestolite plant in Arcade on October 27, 2008. This was a magnificent sight that required a lot of effort on a railroad that takes its role seriously to be the outstanding transportation attraction for western New York. (Photograph by Patrick D. Connors.)

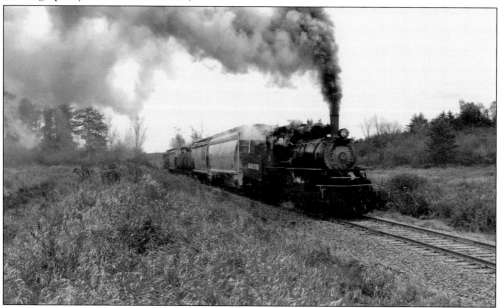

Northbound Arcade and Attica Railroad freight train with locomotive No. 18 is at the top of the grade south of Curriers at the Ludwig Farm on October 27, 2008. This was a captivating moment to rail enthusiasts. With recently upgraded track, this railroad is poised to continue to be the rail artery for southwestern Wyoming County. (Photograph by Patrick D. Connors.)

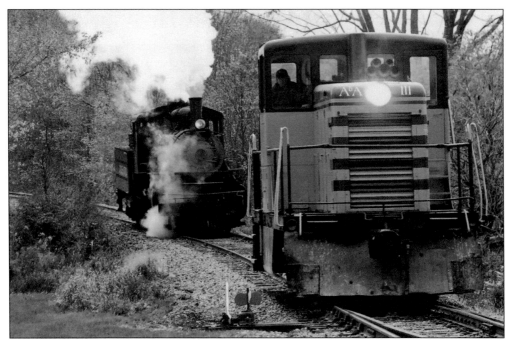

Sam Kish is the engineer on Arcade and Attica Railroad diesel locomotive No. 111, and Brad Mapes is the engineer for steam locomotive No. 18 in the rear at Curriers on October 27, 2008. These two vintage locomotives are handling a freight run. (Photograph by Patrick D. Connors.)

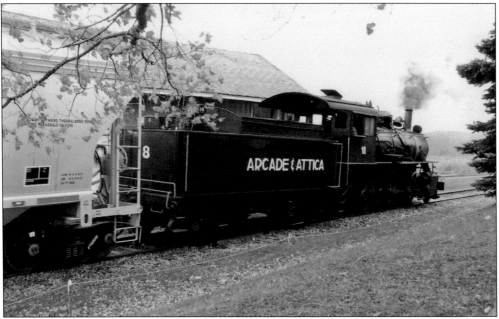

Arcade and Attica Railroad locomotive No. 18 has arrived at Curriers with a northbound freight train on October 27, 2008. This is a railroad that has the management and employees who have the pride and can-do spirit to serve customers and preserve an important part of American transportation history. (Photograph by Patrick D. Connors.)

DISCOVER THOUSANDS OF LOCAL HISTORY BOOKS
FEATURING MILLIONS OF VINTAGE IMAGES

Arcadia Publishing, the leading local history publisher in the United States, is committed to making history accessible and meaningful through publishing books that celebrate and preserve the heritage of America's people and places.

Find more books like this at
www.arcadiapublishing.com

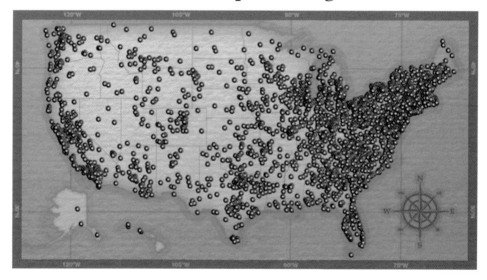

Search for your hometown history, your old stomping grounds, and even your favorite sports team.